LOST
CINCINNATI

To Ryan,

Hope you and the family enjoy this trip through history.

JEFF SUESS

D1603844

THE
History
PRESS

Published by The History Press
Charleston, SC 29403
www.historypress.net

Front cover: Fountain Square decorated for Christmas (circa 1924) showcases much that has been lost in Cincinnati, including (clockwise from lower left) the Hotel Gibson, the Carew Building (with the clock), Rollman's, Mabley & Carew, the Bijou Theatre and the original Fountain Square. About the only thing in the photograph that remains is the fountain itself. *Courtesy of the* Cincinnati Enquirer.

Portions of the text appeared previously in the *Cincinnati Enquirer*.

First published 2015

Manufactured in the United States

ISBN 978.1.62619.575.2

Library of Congress Control Number: 2015937989

For Kristin and Dashiell—my past, my present and my future.

CONTENTS

CONTENTS

ACKNOWLEDGEMENTS

A ny history project would not be possible if it were not for the countless (and sometimes nameless) people who recorded and saved the facts and figures that folks like me dredge through. I offer my immense gratitude to every librarian, historian, researcher, reporter and photographer who chronicled and preserved the history of the Queen City. I am indebted to you all.

The resources listed in the back were invaluable in writing this book. Those authors and historians are the experts in these topics, and I highly recommend each of the books listed—they are a wealth of history knowledge. As the librarian for the *Cincinnati Enquirer*, I had unfettered access to the *Enquirer*'s archives, which go back to April 10, 1841, and many of the photographs come from the newspaper's extensive files, with others filled in from other libraries. Unfortunately, the creators of many historic photographs and newspaper articles are unknown. Credit is given when possible.

Many thanks to Bill Cieslewicz for asking me if I'd like to write history; to Greg Dumais, my commissioning editor at The History Press, for asking me if I'd like to write a book and for guiding me through the process; to copy editor Julia Turner and the designers for making it all look good; to Carolyn Washburn, vice-president and editor in chief of Enquirer Media, for making this book possible; to my family and friends for their support; to Jeremy Suess for making the cover photograph shine; to Jennifer Koehler for her help with the interior photographs; to Angie Lipscomb for taking the author

ACKNOWLEDGEMENTS

photograph; to Cliff Radel for setting the standard; to my colleagues at the *Cincinnati Enquirer* for keeping the flame burning; to Diane Mallstrom and the staff in the Genealogy and Local History Department at the Public Library of Cincinnati and Hamilton County; to Jim DaMico and the staff at the Cincinnati History Library and Archives; most especially to my wonderful wife and partner, Kristin, and our daughter, Dashiell, for being there with me every step of the way and for inspiring me to be better—I love you; and lastly, to Sally Besten, Frank Harmon and the late Ray Zwick for everything I know.

INTRODUCTION

To understand what Cincinnati has lost, we have to see the context of what Cincinnati has been. In the height of the city's stature and influence, Cincinnati was known as the Queen City of the West, noted for its arts, culture, politics and industry. As the first large city west of the Alleghany Mountains, it attracted the biggest and the best in the West.

Cincinnati was founded on December 28, 1788, the second of three settlements along the Ohio River in the untamed frontier of the Northwest Territory. Originally called Losantiville, a composite of syllables loosely meaning "town opposite the Licking River," it beat out Columbia and North Bend as the location for Fort Washington to protect the settlements from the threat of Indian raids. General Arthur St. Clair, the governor of the Northwest Territory, changed the name to Cincinnati after the Society of the Cincinnati, a military organization for Revolutionary War officers. The society, in turn, was named for Lucius Quintus Cincinnatus, a Roman farmer in the fifth century BC who was called to lead Rome into battle and, upon victory, gave up his power to return to the plow—a parallel to George Washington. Steamboat traffic helped to establish Cincinnati as a trading port, and by the 1840s, the bustling city was the center of the meatpacking industry, earning it the nickname Porkopolis. After the Civil War, the railroads routed to Chicago, and Cincinnati's brief stay as a top-ten metropolis had passed.

Not much is left from the city's heyday: a few houses like the Betts House and the Kemper Log House, as well as some cemeteries, though many of

INTRODUCTION

those were lost as well and lie beneath Music Hall and Washington Park. By and large, those days are gone from the city's collective memory. But then another Cincinnati emerged in the late nineteenth century, a midwestern city with its own style and character that is still evident in its architecture, pastimes and identity. This is the Cincinnati people remember, the Cincinnati of Fountain Square and Crosley Field, of the Albee and Peebles' Corner. This is the Queen City that people miss—riding the *Island Queen* to Coney Island and a dance in Moonlite Gardens or taking a streetcar downtown for Christmas shopping at Mabley & Carew. Much of the lamented buildings were lost during the period of urban renewal from the 1950s through 1970s as outdated venues were replaced with modern, less ornamental structures. Others faded away as people's interests and needs changed. Some were neglected or abandoned.

The buildings, attractions and districts that I chose to write about are not all those that have been lost, but they are the ones that have been woven into the character of the Queen City, the ones about which people still hold wistful remembrances or which they wish they could have seen. As a transplant to Cincinnati, I have become increasingly enthralled with the city the more I dig into its past. But the old city is not all lost. As disheartening as it is to look at photographs of the Albee Theater and wonder what it would be like to watch a film in its cavernous auditorium, I delight in walking through the rotunda of Union Terminal, with the exquisite Art Deco detailing and the beautiful mosaic murals—at least for now. The city is losing more of its history, as even its icons are in dire need of restoration. That makes it all the more vital that we pay attention to what is still here and make sure that the Queen City retains its heritage.

Part I
TRAGEDY

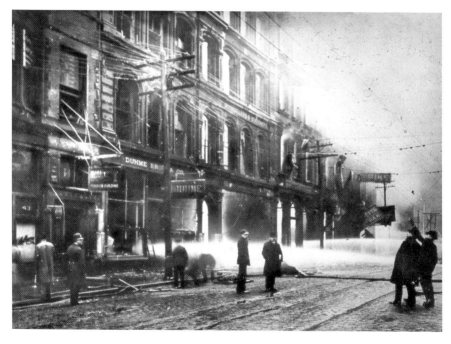

The splendid Pike's Opera House burned down for the second time on February 26, 1903. *Courtesy of the* Cincinnati Enquirer *archives.*

1
PIKE'S OPERA HOUSE

Swedish opera singer Jenny Lind performed four shows in Cincinnati in April 1851 as part of her celebrated American tour. Samuel N. Pike was so enthralled by Lind's performance that the Cincinnati businessman, who built a fortune distilling Magnolia whiskey, was determined to build a showplace that would be worthy of such talent. What he created was one of the finest theaters in the country that would become the center of the city's culture and help establish its musical legacy. The storied Pike's Opera House would then twice suffer great tragedy.

When construction began in 1857, the National Theater had been the Queen City's distinguished venue for twenty years, but Pike raised the bar with his $500,000 opera house. He engaged New York architects Horatio White and John Trimble to design a theater that would be famed for its splendor. Pike's Opera House was situated on the south side of Fourth Street, between Vine and Walnut Streets. Built of bluish-gray sandstone, it stood five stories tall with pronounced pediments over each window. In the center of each level were groups of three arched windows under a single more ornate pediment. The first level, divided by pilasters, had three entrances with the central doors framed in bas-reliefs. An ornamental arched parapet wall that extended beyond the roof featured carved figures representing music, poetry, agriculture and astronomy. At the apex of the arch was a colossal eagle figure, wings spread, perched on a globe. Along the decorative frieze, the understated lettering of "Pike's Opera House" ran between pairs of corbels. The opera house was especially noted for the splendor of its interior,

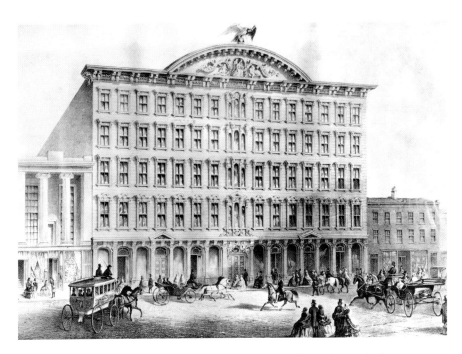

The first incarnation of Pike's Opera House was one of the finest theaters in the country during the Civil War. *Courtesy of the* Cincinnati Enquirer *archives.*

designed by Trimble: the black and white marble tile, a grand staircase and a three-tiered auditorium with elaborate ceiling frescoes.

Pike's Opera House opened with an inaugural festival on February 22, 1859, attracting 2,500 elegantly dressed ladies and gentlemen who declared it the finest of its kind. The opera *Martha* was the first production a few weeks later on March 15. Tickets cost $1.50. Having opened on the cusp of the Civil War, Pike's stage was host to many spirited debates and patriotic speeches. On October 31, 1864, the preeminent thespian James E. Murdock performed the first recitation of the poem "Sheridan's Ride," written that morning by Cincinnati poet Thomas Buchanan Read and destined to be memorized by schoolchildren for generations. The grandest spectacle within its walls was the ball held on September 29, 1860, for the Prince of Wales, the future king Edward VII. Actor Junius Brutus Booth Jr. of the esteemed Booth acting family was performing there on April 15, 1865, when he found out his younger brother, John Wilkes Booth, had assassinated President Abraham Lincoln.

Tragedy struck Pike's Opera House on March 22, 1866. At the end of the evening performance of *A Midsummer Night's Dream*, patrons smelled the

odor of gas. The night watchman turned off the gas jets after the show, but the leak went undiagnosed. At 11:15 p.m., an explosion blew out the rear of the opera house. Fire spread quickly from the stage and burst through the roof. In five minutes, the building was engulfed in flames. Pike heard the fire alarm from his room at the Burnet House and ran to the scene, where he calmly watched his magnificent opera house burn (and, adding insult to injury, a pickpocket stole his watch). *Cincinnati Commercial* reporter Edwin Henderson was an eyewitness to the conflagration, which he recalled in the *Cincinnati Enquirer* under his pseudonym Conteur:

> [B]*y 11:45 the half square bounded by Fourth, Baker, Vine and Walnut had a luridly gleaming dome, through which shot columns of smoke and from which showers of sparks and bunches of flame floated upward and then descended upon the burning mass and upon the brightly illuminated streets, where thousands had already congregated, gazing with awe and sadness upon the scene.*[1]

The roof and arch collapsed, and a chunk of wall fell on the rear of the *Enquirer*'s building. The fire consumed the newspaper offices along with the presses. C.W. Starbuck of the *Cincinnati Times* allowed his competitor to print on the *Times'* presses, and the *Enquirer* missed only one day of publishing. Fire losses totaled more than $1.5 million. Thankfully, no one was killed.

Pike was determined to rebuild. Isaiah Rogers, the pioneering hotel architect who had relocated to Cincinnati, oversaw the design and reconstruction of another, grander opera house on the same site on Fourth Street with the same general features as the first, though expanded to half a block. The chief differences between the two versions were the parapet wall, angular in the new building instead of an arch, and the audience configuration, facing east rather than south as before. D.J. Kenny described the interior of the second opera house:

> *This building, which externally is one of the finest architectural ornaments on the principal street of the city, is in its interior adornment the most beautiful perhaps in the United States…*
>
> *The proscenium is remarkable for its wealth of architectural beauty and delicacy of finish. The whole house is elaborately frescoed. Marbling is used about the coves, the ceiling and paneling large and small every-where, and in the magnificent proscenium with wonderful effect.*[2]

Medallions and painted panels depicted mythological and symbolic figures along with a phoenix atop a shield. Full-figure statues stood on the elaborate structures on either side of the stage, creating the effect of classic temples within the auditorium.

Pike's Music Hall opened on February 12, 1868; three years later, the music hall was remodeled into an opera house and the name was restored. At the same time, Pike built another Pike's Opera House in New York City that became the Grand Opera House when he sold it in 1869. (It also burned down after it closed in 1960.)

In Cincinnati, history would repeat.

At 1:29 a.m., on February 26, 1903, the fire alarm went off in the Adams Express Company offices in the Pike Opera House. Flames crept through the Pike building, and a ten-blow alarm was sounded, signaling a major fire. Crews of firefighters rushed to the scene and pumped in streams of water, but the heat was so intense that the water seemed to evaporate into steam. Flames consumed the opera house and stores in the Pike building and spread to the neighboring L.B. Harrison and American Book Company properties. Firefighters fought the inferno for hours, finally getting it under control about 5:00 a.m.

The fire was one of the worst and most spectacular in the city's history, destroying half a block of one of its most prominent streets. Pike had passed away in 1872, so there would be no rebuilding this time. The hulk of ruins lay in the Fourth Street lot as an eyesore for two years before it was cleared to build the Sinton Hotel, an elegant hotel that would also be one of Cincinnati's jewels for many years. Though Pike's Opera House can scarcely be mentioned without reference to the fires, Samuel Pike's legacy is not its loss but the city's embracing of the arts.

2
HAMILTON COUNTY COURTHOUSE

Three different versions of the Hamilton County Courthouse met their fates in fires. One of them famously was burned during the darkest days in Cincinnati history.

Hamilton County was established on January 4, 1790, by proclamation of General Arthur St. Clair, the first governor of the Northwest Territory. According to Judge Jacob Burnet, the earliest courts met in a room rented in a tavern near the frog pond at the corner of Fifth and Main Streets with all the trappings of a court: a pillory, stocks and a whipping post.[3] A log house nearby was used as a jail. With Cincinnati prospering as a trading center, a new courthouse designed by Judge George Turner was erected on the same site in 1802 at a cost of $3,000. This was a substantial limestone structure, two stories tall with parapet walls and a wooden domed cupola surrounded by balustrades. Early Cincinnatians took pride in the handsome building, but it would not last long. The courthouse was used as a soldier barracks during the War of 1812, and early in 1814, it was accidentally set on fire and destroyed by careless soldiers playing cards.

Jesse Hunt donated a plot of land to the county for a new courthouse on Main Street in what at the time was considered outside the town. The adjoining road was called Court Street because of the new courthouse. The $15,000 structure was a square Federal-style building made of brick with a tall steeple. The courtroom extended across the entire length of the building; a second courtroom was later added upstairs. When the courthouse was completed in 1819, it stood in the middle of the lot surrounded by grass

and shrubs and was criticized for its remoteness, but over the next couple decades, as Cincinnati's population boomed, the city grew out to meet it. That growth also meant the courthouse became inadequate, and wings were added for more offices. When fire spread from a nearby building to the court's roof and steeple on July 9, 1849, there was little rush to save "the old courthouse." The *Enquirer* reported, "The firemen were on the ground, but did not appear to have any wish to arrest the progress of the flames. The burning apparently gave general satisfaction, for this progressive age is extravagant in its ideas of public buildings." An epitaph was added that could apply to the demise of several of Cincinnati's lost buildings: "Old age is honorable but very unpopular."[4] Until a new courthouse could be built, the courts were held in a nearby pork house.

In 1851, contracts were awarded for the sum of $695,253.29 for a new courthouse and jail based on the plans of acclaimed hotel architect Isaiah Rogers, fresh off his triumph of the celebrated Burnet House. Rogers's courthouse plans called for a monumental stone structure with an impressive row of Corinthian columns and a bold Classical pediment. Four wings extended out at right angles from a large rotunda hub that was surmounted by a magnificent two-hundred-foot-high dome. Legal challenges to the contracts caused numerous delays, and the plans for the dome were scuttled. Architect James Keys Wilson, who would later design Plum Street Temple and the entrance to Spring Grove Cemetery, helped to complete the courthouse in 1853. The courthouse lasted just over thirty years before it, too, was destroyed by fire.

The decade of the 1880s was one of turmoil and crisis in Cincinnati. The city was a sometimes-volatile mix of races and ethnicities all residing in the basin, though the wealthy were able to escape to the hilltops and establish suburbs. Tensions brewed to a boiling point regarding the everyday occurrence of violent crime. In March 1884, the *Enquirer* spoke out: "Time was when Cincinnati needed but twenty-five policemen to guard its moral safety…[N]ow, with but little increase in territory, a police force of three hundred men and five patrol wagons…its streets reek with crime. Not a thoroughfare in its limits but has been stained with human blood." The *Enquirer* blasted not only the criminals but also the city's response to them, claiming that in the past year, ninety-two people had been arrested for murder or manslaughter but only four men had been hanged. "Laxity of laws give the Queen City of the West its crimson record."[5]

One of the crimes that triggered the outburst was the murder of William H. Kirk on Christmas Eve 1883. The livery man was beaten, strangled and

robbed by two of his employees, William Berner, a German immigrant, and Joseph Palmer, of mixed race. The *Enquirer*'s essay had stoked public interest in the trial of Berner, so the courthouse was packed on March 24, 1884, when the jury declared Berner guilty of only manslaughter. The incensed crowd called for a hanging. Even Judge Samuel R. Matthews forgot his decorum and called the verdict "a damned outrage."[6] "Never was there a verdict in a criminal case that caused as much open and unfavorable comment," the *Enquirer* wrote.[7]

Cincinnatians were fed up. On Friday, March 28, prominent citizens held a mass meeting at Music Hall so that the citizens' frustrations could be heard, though some among the eight thousand in attendance called for a vigilance committee, or vigilante posse. After the meeting adjourned, someone cried, "Let's hang Berner!" and incited a mob to march to the jail. Sheriff Morton L. Hawkins told the crowd that Berner had already been moved to the penitentiary (during which time Berner had temporarily escaped custody), but that didn't appease the mob, which had grown to ten thousand in number. Armed with sticks, hammers, crowbars and a battering ram, people stormed the jail. To avoid making the situation worse, Sheriff Hawkins ordered his men not to fire on the rioters. The Ohio National

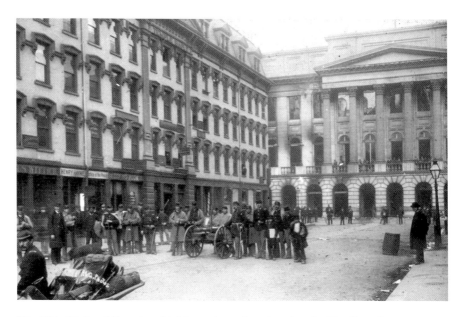

The Ohio National Guard couldn't keep rioters from burning the Hamilton County Courthouse in 1884. The damage can be seen through the courthouse windows. *From the Collection of the Public Library of Cincinnati and Hamilton County/Rombach & Groene.*

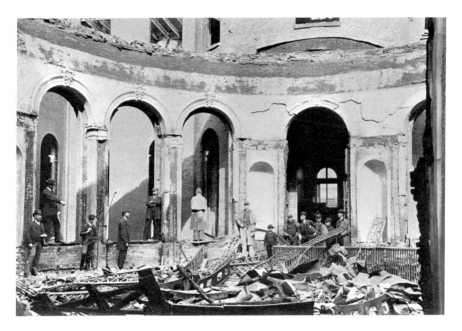

The rotunda of the courthouse where the trial of William Berner was held was in ruins after the courthouse riots. *Courtesy of the* Cincinnati Enquirer *archives/Rombach & Groene.*

Guard arrived and fired blank rounds to scare them off, but the rioters and militia tangled until 3:00 a.m. The next morning, the *Enquirer* praised the response of the people with the headline: "At Last the People Are Aroused, and Take the Law in Their Own Hands."[8]

After a calm afternoon on Saturday, March 29, nightfall brought another mob to the jail, encouraged by the *Enquirer*'s validation, and it again met the militia. The courthouse next to the jail was left unguarded, so the mob broke in there, smashed up the offices and set it on fire. The volumes of paper files burned like kindling, and irreplaceable documents and records from the beginning of the county's settlement were lost forever. While the courthouse was in flames, the militia fired on the crowd with Gatling guns. "Fire and Fury, The Reign of Terror…Terrible Carnage and Slaughter On the Streets"[9] is how the *Enquirer* headlined the terrible turn of events; the editors, perhaps, regretted the actions they had helped to arouse. The courthouse was gutted by the fire, save for the outer walls. The loss of county records and the estimable Law Library added to the tragedy. The newspaper finally asked: "Was it worth while to inflict this great damage upon ourselves…?"[10]

On Sunday, the militia barricaded the hulking ruins of the courthouse and defended the mob surges with the Gatling gun. After three horrific days,

the people dispersed. Tallies varied, but about fifty people were killed in the courthouse riots and a few hundred more wounded. Among those killed was Captain John J. Desmond of the First Regiment. A statue honoring Captain Desmond stood for many years in Lincoln Park and now resides in the current courthouse. The 1884 riots and ineffectual legal system led to

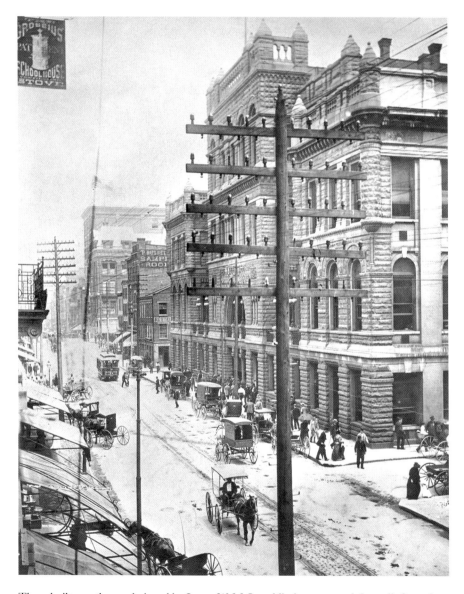

The rebuilt courthouse designed by James W. McLaughlin incorporated the walls from the building destroyed in the riots. *Courtesy of the* Cincinnati Enquirer.

sweeping political change and the notorious reign of George Barnsdale Cox, known as Boss Cox.

Prolific Cincinnati architect James W. McLaughlin was chosen to rebuild the courthouse using the two end walls that remained. Influenced by the Romanesque style of Boston architect H.H. Richardson, McLaughlin created a façade of rough stone that wasn't a complete fit with the austere lines of the Rogers courthouse. The entrance was a two-story arch divided by columns and a lintel. The corners and the balustrade on the roof were capped with pyramids; the rounded corners of the wings ended in cones. Completed in 1886, the courthouse wasn't received as warmly as its predecessor, but the Hamilton County Bar was pleased enough to throw a banquet for the courthouse commissioners and McLaughlin. The courthouse had a short tenure and was demolished in 1915 for a more spacious structure. Construction proceeded throughout World War I at a cost of $3 million, and the courthouse was dedicated on October 18, 1919. The Beaux-Arts Classical courthouse designed by John H. Rankin of the Philadelphia firm Rankin, Kellogg & Crane evoked the structure and dignity of the law, echoing the Rogers design with an imposing order of Ionic columns. It stands strong after nearly a century.

3
CHAMBER OF COMMERCE BUILDING

A curious gathering of stones stands like ancient ruins on a grassy knoll in Burnet Woods, to the north of the University of Cincinnati. To passersby, it is merely a curiosity. Few know of its purpose as a monument to one of the country's greatest architects. Students and faculty of UC's architectural program erected the H.H. Richardson Memorial to commemorate the acclaimed architect, using stones culled from the remains of one of his final designs, the Cincinnati Chamber of Commerce Building, which was destroyed by a fire in 1911. Were it standing today, the building would likely be one of the city's crowned jewels, along with Music Hall, Union Terminal, City Hall and the Roebling Suspension Bridge, for its pedigree alone.

Architect Henry Hobson Richardson is one of "the recognized trinity of American architecture"[11] along with Louis Sullivan and Frank Lloyd Wright. Richardson was born in St. James Parish, Louisiana, in 1838 and grew up in New Orleans. Educated at Harvard and the *École des Beaux-Arts* in Paris, Richardson reasserted the original principles of design from Classical architecture. He made a name for himself with his design for Trinity Church in Boston's Copley Square in 1872. He was a swarthy, bearded man of huge proportions and immense vitality, known to favor dressing up in medieval garb. From his studio in Brookline, Massachusetts, he drew up plans for libraries, railroad stations and public buildings throughout the Northeast. The Chamber of Commerce Building was Richardson's only design in Ohio. His reintroduction of Romanesque forms, using round arches and the "bigness" of rock-faced granite, became a style known as Richardsonian Romanesque.

The style heavily influenced American architects in the late nineteenth century, including Cincinnati's leading architects Samuel Hannaford and James W. McLaughlin. Hannaford's Cincinnati City Hall, completed in 1893, was inspired by Richardson's Allegheny County Courthouse (1888) in Pittsburgh and is the region's best example of Richardsonian Romanesque architecture since the Chamber of Commerce Building was destroyed.

The Cincinnati Chamber of Commerce and Merchants' Exchange had agreed to build a permanent home in 1884, having previously met in Pike's Opera House. The chamber of commerce purchased the site of the U.S. Post Office and Custom House on the southwest corner of Fourth and Vine Streets and held a competition for designs; Richardson's plan was chosen over those of the likes of McLaughlin and Hannaford. His plan may have been "strictly utilitarian," as Richardson himself described it, for its purpose as a civic building, featuring open spaces and high windows to allow natural light to every room, but the design was intended to provide a structure whose character "should depend on its outlines."[12] In that he succeeded, offering up a grand stone building that evoked the image of a castle, with rounded towers and conical roof turrets that anchored the corners and hand-carved window arches.

At the time, the selection of Richardson's design drew great attention in architectural circles, though the famed architect would never see it built. Shortly after completing the drawings of the Chamber of Commerce Building, Richardson succumbed to illness in 1886 at the age of forty-seven.

Construction on the building began the next year. Pink granite gave the structure of rough-hewn stone a rosy hue. The most striking feature was the sequence of arched windows, three stories tall, with intricate decorative stone carvings. Atop the eight-story building, the cones and pointed roof were of red tile. Above the cornice, bridged between the turrets, was a row of dormer windows with single dormer windows on the north and south faces. Perched on those were four carved granite eagles. The Flour and Grain Exchange building in Boston—built by Richardson's successors, Shepley, Rutan and Coolidge—has many of the same characteristics as the Chamber of Commerce Building, including the design of the arched and dormer windows.

The building entrance was on the westernmost side of the Fourth Street front. The openness of Richardson's design was expressed in the massive Exchange Hall, which occupied the second floor and extended three stories in height. The large room received natural light through the tall arched windows and was free of any supporting columns to break up the great

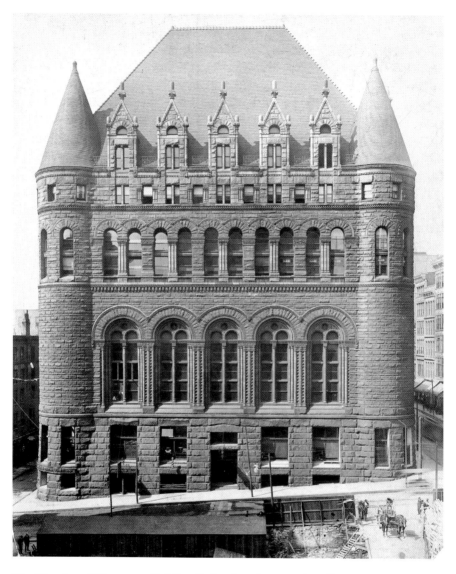

The Chamber of Commerce Building displays key elements of the Richardsonian Romanesque style, such as rough stone and arched windows. Construction sheds for the Sinton Hotel are visible in the foreground. *Courtesy of the* Cincinnati Enquirer *archives.*

space. This was accomplished by suspending the top three stories by steel trusses. That design would lead to catastrophe.

George Stuart Bradbury, clerk of the Cincinnati Chamber of Commerce during the building's construction, wrote that "a description…and indeed

even photographs of the building, give but an inadequate and superficial idea of its quiet beauty and impressiveness. It should be seen to be fully grasped and appreciated."[13]

The chamber of commerce's new home was dedicated over January 29–30, 1889. The building, costing $772,674.05, was widely acclaimed, with some of the praise likely due to it being Richardson's last major work. The *Enquirer* called it "an architectural wonder" that would be "an enduring monument to [Richardson's] genius and taste."[14] However, Richardson scholar Henry-Russell Hitchcock denigrated the design. "The towers are too tall and narrow to be merely great bulges on the corners," he wrote, "and yet they are not incidental enough to be mere decorative turrets." Hitchcock felt that Richardson's "powers were declining" and that the building was below the standard of the many Richardson imitators. "Richardson was being worked to death, and his work was dying even before he did," Hitchcock wrote. "In this sense, the Cincinnati Chamber of Commerce can be called posthumous. Its destruction by fire was no great loss."[15] But the building wasn't the only loss.

On the night of January 10, 1911, the West End Business Club held a banquet in the Business Men's Club on the seventh floor. At 7:30 p.m., an overheated kitchen range ignited the woodwork. The fire gained headway, but there was no panic, no urgency. The banqueters remained seated for fifteen minutes before they were told to evacuate in an orderly fashion. Upstairs, the fire engulfed the roof. The heat added strain to the truss girders and stripped the bolts, and the tower roof and upper floors crashed on top of the bottom levels. The explosion blew out the windows of the Burnet House to the south and the Sinton Hotel across Vine Street and could be heard from blocks away. Dozens of firemen and bystanders were struck by debris. Six people never made it out: Brent Marshall, Charles S. Sibbald, Lester Buchanan, night fireman Christian Meents, engineer Fred Selm and George Frank Hayman, an eighteen-year-old *Enquirer* reporter who had run into the building to cover the story moments before the collapse. All were crushed to death under the wreckage.

The building was destroyed in an hour, but the strong granite walls remained intact. Damages were estimated at $1 million, but the chamber of commerce held only $105,000 in insurance, making it a total loss. The walls were demolished, but the stones were preserved. The carved eagles from the roof were mounted on piers along Eden Park Drive beneath the Melan Arch Bridge near the Krohn Conservatory. The building site was purchased by the Union Central Life Insurance Company to build an immense tower, which,

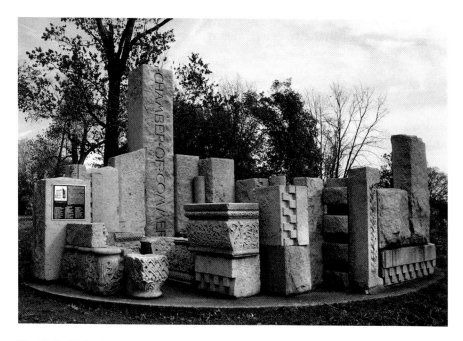

The H.H. Richardson Memorial in Burnet Woods, built by University of Cincinnati students to honor the great architect, used the remains of Richardson's Cincinnati Chamber of Commerce Building. *Courtesy of the author.*

at twenty-nine stories, was the fourth-tallest building in the world at the time, costing a staggering $3 million. The signature Union Central Life Insurance Building, now called PNC Tower, has helped define the Cincinnati skyline since it was completed in 1913.

The Cincinnati Astronomical Society salvaged three thousand tons of granite from the Chamber of Commerce Building ruins. The stones were stored in Oakley for a while until they were finally shipped by rail out to Buffalo Ridge Road in Cleves, where the plan was to use them to build an observatory. The design by Garber & Woodward would feature the graceful window arches repurposed from Richardson's building. But money dried up during the Great Depression, and the observatory was never completed. The stones were abandoned in the field. Curious explorers concocted stories that the stones were part of an exploded asylum, and the site was rumored to be haunted.

Ted Hammer, an architectural student at the University of Cincinnati (UC) in 1967, heard about the stones during a lecture and decided to drive out to the field in Cleves, now the Mitchell Memorial Forest. There he found hundreds of hand-carved stones strewn across the field, snarled in foliage and

poison ivy. It was the remnants of Richardson's final masterpiece. Hammer had the idea for a student project to reuse the stones for a monument to Richardson. He called it "Operation Resurrection." Student Steve Carter won the monument design competition with a stone circle inspired by stacks of coins. Carter selected fifty-one pieces, including many from the carved arches, and used the massive lintel etched with "Chamber of Commerce" as the central column. The students dug up the stones with bulldozers and transported them to Burnet Woods, where the monument was erected in 1972. It now faces UC's College of Design, Architecture, Art and Planning across the street, serving as inspiration. In 2013, the city declared the remaining stones in the forest a hazard and ordered their disposal.

Part II

TRANSPORTATION

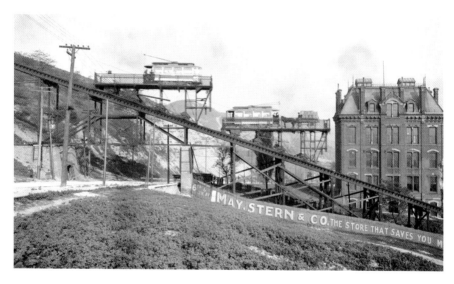

Streetcars and a horse-drawn wagon ride the Bellevue Incline past the University of Cincinnati building on the Charles McMicken estate. *Courtesy of the Library of Congress/Detroit Publishing Company.*

4
MIAMI & ERIE CANAL

As the first settlements cropped up in the Northwest Territory in the 1780s, George Washington, who had surveyed the Ohio Valley, suggested a canal to connect Lake Erie with the Ohio River as an inland transportation system that could carry goods from the northeast to the south and all points in between. The Ohio Canal Commission was finally started in 1822 to map out routes. The eastern Ohio & Erie Canal would connect Lake Erie at Cleveland down to the Ohio River at Portsmouth. Construction began near Newark, Ohio, on July 4, 1825. The western canal route, known as the Miami Canal, was started two weeks later in Middletown. The Miami Canal extended to both Cincinnati and Dayton by 1828 and finally reached the Ohio River in 1833. After the Wabash & Erie Canal was completed from Evansville, Indiana, to Toledo, Ohio, all the canals from Toledo to Cincinnati were renamed the Miami & Erie Canal in 1849 for the sake of convenience.

Construction of the canal was swift, done mostly by Irish and German immigrants for thirty cents a day. Malaria and cholera were rampant and deadly, and the workers often coped with whiskey. The full Miami & Erie Canal covered three hundred miles and cost $8 million. The canal trenches were twenty-six feet wide at the bottom, lined with sandstone, and forty feet wide at the waterline to accommodate two-way traffic. The water was a minimum of four feet deep. In order to match the water levels and different elevations along the canal route, there were more than one hundred locks. Boats entered a chamber, then miter gates enclosed the chamber and the

water was raised or lowered to equal the next section of the canal. The locks measured ninety feet long and fifteen feet wide, which determined the dimensions of the boats that had to fit inside. The typical canalboat was eighty feet long and fourteen feet wide. Packet boats were strictly for passengers and were more elaborate than line boats and freight boats. The captain's family and the crew lived on board in cramped quarters. The canalboats weren't powered; they were pulled at the end of a towrope tethered to a horse or a mule that walked the ten-foot-wide towpath along the bank. Needless to say, travel by canalboat was not fast. A mule towed at about two and a half miles per hour, and each lock took fifteen minutes to negotiate, resulting in small towns sprouting up to tend to passengers waiting at the locks.

In November 1843, former president John Quincy Adams, then seventy-six years old, was invited to Cincinnati to lay the cornerstone of the Cincinnati Observatory. Upon reaching Ohio, Adams and his party traveled from Akron to Hebron and then took a stage the rest of the way to Cincinnati. His account of the trip provides an excellent glimpse of traveling by canalboat:

I came on board of the canal packet-boat Rob Roy *yesterday very unwell with my catarrh, hoarseness, and sore throat, and some fever. This boat is eighty-three feet long, fifteen wide, and had, besides the persons I have named, about twenty other passengers. It is divided into six compartments, the first in the bow, with two settee beds, for the ladies, separated by a curtain from a parlor bed-chamber, with an iron stove in the centre, and side settees, on which four of us slept, feet to feet; then a bulging stable for four horses, two and two by turns, and a narrow passage, with a side settee for one passenger to sleep on, leading to the third compartment, a dining hall and dormitory for thirty persons; and, lastly, a kitchen and cooking apparatus, with sleeping-room for cook, steward, and crew, and necessary conveniences. So much humanity crowded into such a compass was a trial such as I had never before experienced, and my heart sunk within me when, squeezing into this pillory, I reflected that I am to pass three nights and four days in it…*

The most uncomfortable part of our navigation is caused by the careless and unskilful steering of the boat into and through the locks, which seem to be numberless, upwards of two hundred of them on the canal. The boat scarcely escapes a heavy thump on entering every one of them. She strikes and grazes against their sides, and staggers along like a stumbling nag.[16]

TRANSPORTATION

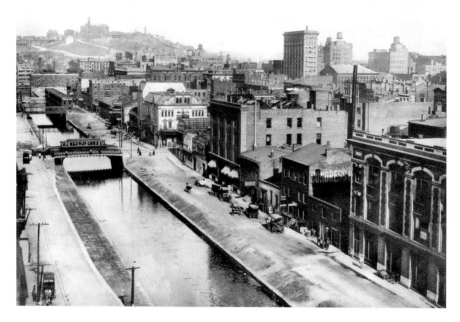

The Miami & Erie Canal ran across downtown along the current route of Central Parkway, looking east from Race Street. Mount Adams appears in the distance. *Courtesy of the* Cincinnati Enquirer *archives.*

The Miami Canal reached downtown Cincinnati in 1829. The canal route ran where Central Parkway is today, ending at Lockport Basin, west of Sycamore and north of Court Street. When the basin proved inadequate, the larger Cheapside Basin was built where East and West Cheapside Avenue are now, nearly to Eighth Street. Canal Street flanked the canal from the basin to the Plum Street "elbow" (where Central Parkway bends). The final canal section was a diagonal path to the Ohio River along present-day Eggleston Avenue, ending approximately between the current Daniel Carter Beard and L&N Bridges. Completed in 1833, it ended up rarely being used. There were ten locks in that stretch, so it was time-consuming to pass through twenty locks in a round trip, and cargoes were broken up and distributed before reaching that point. So in 1863, the river extension was abandoned and paved over.

The golden age of the canal system was relatively brief. Almost as soon as the canal was completed, the steam railroads started coming. Though transport by rail was more expensive than by canal, railroads could reach more places and did not require natural waterways. After the Civil War,

railroads were the dominant mode of transportation for both passengers and cargo, and over the next few decades, interurban electric railroads developed to connect midwestern cities, though the canal service limped along, usually carrying bulk cargo. Critics found the canals to be cesspools that bred disease and foul odors even though children used them as swimming holes. The Cincinnati Hospital, situated along the canal at Twelfth Street and Central Avenue, was concerned about severe health hazards with mosquitoes and waterborne diseases and had to relocate.

One bright spot for the canal was its memorable inclusion in the Centennial Exposition of the Ohio Valley and Central States, held in Cincinnati from July 4 to November 8, 1888, to commemorate the Queen City's 100th anniversary. This would be the last of the expositions the city hosted in the 1880s and the most meaningful for the city. Music Hall, completed in 1878, was built for just this sort of occasion, so naturally it was the permanent building that anchored the temporary exposition structures. A covered bridge spanning Elm Street connected Music Hall to the temporary Washington Park Building, an elaborate hall designed by architect H.E. Siter. It featured a central octagonal tower flanked with smaller towers and more towers on the ends of the wings, each topped with cone turrets and flags, giving the appearance of a medieval fair. Behind Music Hall and running along—in fact, *over*—the canal, covering three blocks from Twelfth to Fifteenth Street, was the immense Machinery Hall, designed by James W. McLaughlin. The canal ran through the middle of the hall, with four bridges spanning the waterway. The effect was a Venetian scene accompanied by gondolas imported from Italy for the event. Visitors could ride the boats along the canal and imagine they were in Venice. The purpose of the hall was to exhibit new machinery of the Industrial Revolution displayed in the aisles on both sides of the hall, but it was the canal that made a lasting impression to the million visitors who attended the exposition.

The *Graphic*, a weekly Cincinnati newspaper, recommended getting rid of the canal in its September 27, 1884 issue: "The changes which time brings in all things cause many heartaches, but the heartaches of those who cling so fondly to the dead old ditch can in no degree compensate for the malarial headaches of hundreds who must suffer from its influence."[17] The accompanying illustration, labeled "A Dream of the Graphic," depicted the specter of death hovering over the canal and dilapidated buildings while a woman dreamt of a boulevard lined by handsome multistory buildings over an underground railroad.

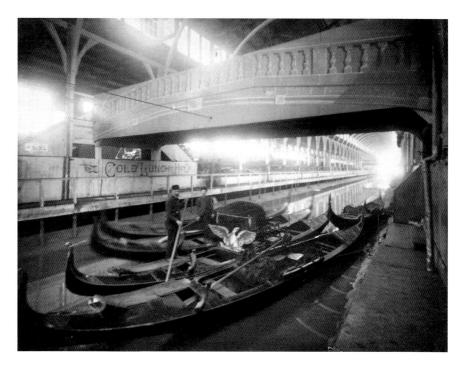

Gondolas were a popular attraction on the canal through the Machinery Hall at the Centennial Exposition. *Courtesy of the* Cincinnati Enquirer.

The idea of replacing the canal resurfaced in 1907, when landscape planner George E. Kessler was asked to develop a city park system for Cincinnati. The Kessler plan proposed that the canal, which the report called "unsightly and of little value," be paved over for Central Parkway, "a grand boulevard one hundred and fifty feet wide over all, with a driveway on each side of a continuous central park space"[18] to feature gardens and fountains. Not only would the boulevard be "a wide passage into the very heart of [the] business center," it would also clean up the health hazard the canal had become. Further plans called for a twin tunnel subway to be run underneath Central Parkway, so that project was started first. After World War I, the remaining Cincinnati canal beds were excavated starting at Broadway Street and going north to build tunnels for the subway, but due to lack of funds and interest, as well as changing transportation needs, the subway was abandoned. Central Parkway opened on October 1, 1928, though only the east–west section downtown had much in the way of a park and without the gardens. The unused subway tunnels are still under the parkway.

Officials turned the water off at Middletown in 1929, and the Miami & Erie Canal dried up. Some vestiges of the canals remain. Lock No. 17 was relocated to Carillon Park in Dayton, where visitors can view the mechanics of the system. Tourists can still ride canalboats in Metamora and west central Indiana. In Cincinnati, a canalboat and its crew are forever docked in Michael Carrollton's ArtWorks painted mural on Central Parkway as a reminder of the canal era.

5
THE CINCINNATI SUBWAY

The Cincinnati subway was not so much lost as it was a lost opportunity. With a subway, Cincinnati may have developed more like Chicago; on the other hand, part of the Queen City's charm is that it is more manageable than the megacities. Regardless, Cincinnati would have become a different city had the subway been completed.

After the illustration in the *Graphic* suggested an underground railroad in 1884, the idea popped up again in 1907 with the Kessler plan's Central Parkway design, which would utilize the old canal bed. When Democrat Henry Hunt took office as mayor in 1912, he inherited a city that had been under the thumb of the Republican political machine of George Barnsdale Cox, the self-proclaimed "Boss of Cincinnati." Under his control, the Queen City had garnered a reputation as "the worst governed city in the world."[19] Part of Hunt's plan to reduce city congestion was to decentralize the population by offering rapid transit to the suburbs. Several key pieces came into place quickly. In 1911, the city had leased the canal with the idea of creating the proposed Central Parkway. The next year, Hunt appointed the Interurban Rapid Transit Commission to suggest alternatives for electric railway travel, and it hired Bion J. Arnold, a Chicago engineer. Arnold's report suggested a train with a fifteen-mile belt line and downtown loop, part of which would be underground, and recommended using the bed of the canal. Hunt was defeated for reelection in 1913, and the Republicans were back in power; however, they, too, favored rapid transit.

A report by F.B. Edwards and Ward Baldwin in 1914 outlined four "schemes" for proposed routes. Each outlined a loop route with some variation. The commission chose Scheme IV, which would cost $11 million for construction, plus another $2 million for the subway cars, stations and equipment. The "subway" would actually have both underground and open portions running on two tracks in a 16.46-mile loop. Beginning at Fourth and Walnut Streets, the route would run north on Walnut to the canal bed, which it would follow to Ludlow Avenue. Then it would pass through St. Bernard and Norwood, then down Madison Road to Columbia Avenue and back downtown along Third, Pearl and Walnut Streets.[20] The commission balked at the price tag and demanded modifications to bring the cost down to $6 million. Voters approved the bond issue for that amount in 1916 and, the next year, passed an ordinance to build the rapid transit and have the Cincinnati Traction Company operate it. But in March 1917, the Ohio Supreme Court declared the ordinance invalid because it had the city lending its credit to the traction company. The next month, the United States entered World War I, and the subway was put on hold until the end of the war.

When the project was to resume in 1919, the Rapid Transit Commission discovered that costs of materials had nearly doubled during the war, so plans were scaled back again to build only the western portion of the subway for the $6 million approved. The line would make it as far as St. Bernard and Norwood. Construction began in January 1920, but delays and unexpected expenses led to concerns over funding. In 1927, Mayor Murray Seasongood ordered a new study of the city's rapid transit needs. Seasongood was part of a new Cincinnati political party known as the Charterites, Republican reformers out to overturn the corrupt Boss Cox machine and restore the city's financial footing. The Beeler Report found that while Cincinnati was not a large city, its topography—the basin and the many hills—and its placement as a major industrial city made rapid transit a necessity, but it also warned that it would take another $10.6 million to complete the project. The price tag was too much for the political reformers. Seasongood had open conflicts with the Rapid Transit Commission, which he viewed as a holdover of the Boss Cox era. He vowed that no more work would be done on the subway until the commission's terms expired on January 1, 1929. Even as Central Parkway opened in October 1928, the subway tunnels underneath it went quiet. Then the stock market crash in October 1929 triggered the Great Depression, and building a subway was no longer a priority. Furthermore, the demise of the interurbans, which were to connect with the subway lines,

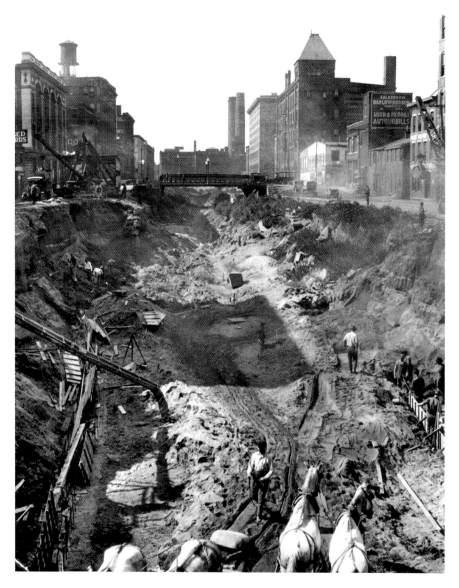

The canal bed was dug up for the proposed subway in 1920 and would be covered by Central Parkway. *Courtesy of the* Cincinnati Enquirer.

and the sudden rise of the automobile meant there was less need for a rapid transit train. Basically, construction was just abandoned.

The subway project would periodically gain some traction, especially as other cities developed systems. But the lands for the rapid transit loop conflicted with plans for new highways, and none of the attempts to complete

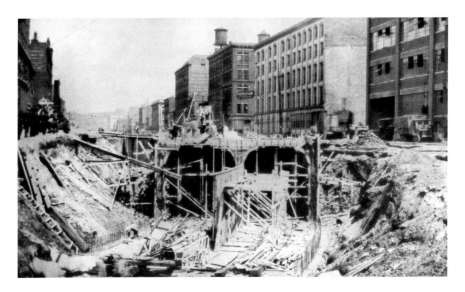

The twin subway tunnels built underneath the "elbow" of Central Parkway are part of the few miles of tunnels completed before the project was abandoned. *Courtesy of the* Cincinnati Enquirer.

the subway panned out. In 1962, during the cold war, the finished Liberty Street subway station was converted into a fallout shelter in the event of a nuclear war. Proposals for light rail usually included utilizing the existing subway tunnels, but voters defeated the most recent plan in 2002.

Since the subway tunnels support Central Parkway, the city continues to maintain them. Though marred with graffiti, the walls appear nearly as good as new. About 2.2 miles of the tunnels lie underneath Central Parkway, starting between Walnut and Main Streets, on up to Hopple Street. Underground stations remain at Race, Liberty and Brighton Streets, and a few boarded-up tunnel entrances are visible along Interstate 75, near where the aboveground Marshall Street Station had been.[21] Occasionally, there are "subway tours" down into the depths of the completed but unused tunnels, feeding people's endless fascination with what might have been.

6

THE INCLINES

The early settlers founded Cincinnati in a flat, crescent-shaped basin surrounded by hills. This topography was a key reason why the settlement was chosen for the location of Fort Washington; it was easily defensible and less prone to flooding. The city grew and developed over half a century, and by the 1850s, the basin was congested with people, factories and their byproducts—soot and waste. People wanted to move outside the city, up on the hills, but transportation was troublesome. The first attempt, around 1850, was a horse-drawn omnibus: a team of four horses would pull a bus loaded with a dozen passengers up to Mount Auburn. The trip, with frequent stops for the horses, took about thirty minutes. Steam-powered streetcars weren't the answer because they emitted sparks that spooked the horses sharing the road with them.

Brothers Charles and John Kilgour hoped a streetcar would spur development of their real estate in the suburbs east of the city. In 1866, they started the Columbia & Cincinnati Street Railroad to run their dummy train. Steam dummies had lower-pressure condensing engines that made less noise when releasing steam and were disguised as passenger cars—or dummy cars—to fool the horses. The first line ran from Fulton, where the horsecar service from the city ended, down Eastern Avenue into Columbia. Later, a branch was added up Delta Avenue to Mount Lookout Square. There were two types of dummy cars: a steam locomotive and another in which passengers shared the car with the smoky steam engine. The wheels were modified for narrow-gauge track, making for a wobbly ride. The

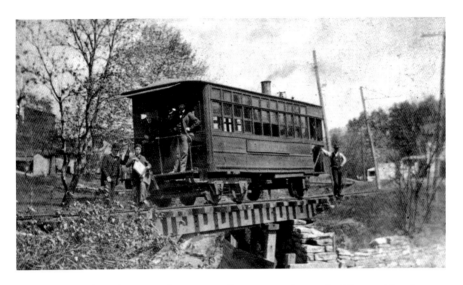

The Mount Lookout dummy train was an early transportation method for reaching the suburbs. *Courtesy of the* Cincinnati Enquirer *archives.*

dummy was never profitable, although the suburbs Hyde Park and Mount Lookout did take root. The rail lines were consolidated into the Cincinnati Street Railway Company and were converted to electric streetcars. On New Year's Day 1898, a mock funeral and cremation service was held for the Mount Lookout dummy. The two dummy cars were set on fire while a band played a funeral dirge, and then the ashes were interred along the tracks.

In Pittsburgh, a similar hill problem was solved with inclined plane railroads, also called funiculars. That city's first passenger incline, the Monongahela, was built in 1870 and is still in operation. Cincinnatians knew a good idea when they saw it, and soap maker Joseph Stacy Hill and his partner, George A. Smith, constructed their own incline from the end of Main Street up to Mount Auburn. The Main Street Incline, also known as the Mount Auburn Incline, opened on May 12, 1872. Twin railroad tracks ran up the hillside to the powerhouse, where two steam engines with large windlasses—cylinders turned by crank—pulled steel cables to raise and lower the cars along the tracks. One car went up as the other went down, like on a pulley system. The platform for the car was elevated in the rear so that the car was kept horizontal and not angled. Six thousand passengers rode the first day. The *Enquirer* called it the end of the hills being the sole provenance of the wealthy:

TRANSPORTATION

The barbarians of the lower plane have at length sealed the rugged ascent to their fastnesses, and will soon be besieging their castle gates, clamoring for admission to the broad fields, the sunny slopes and the pure air of the upper plateau. And there they will build their homes, leaving the city with its crowded streets, its smoky, begrimed houses, its odors and its filth to commerce and manufacturers.[22]

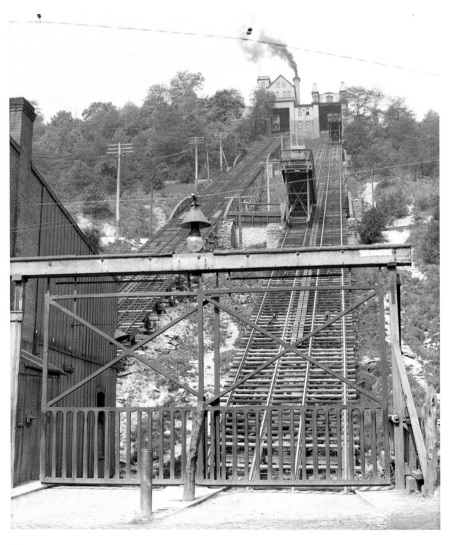

The Price Hill Incline, with one track for passengers and another for freight, made it possible for people to move to the West Side neighborhood. *Courtesy of the Library of Congress/Detroit Publishing Company.*

That fall, the owners opened the Lookout House on the hill, a resort that provided food, refreshments and music. It was a plain, two-story establishment with an elevated deck that offered a spectacular view of the city below. An opera house auditorium was added, and in later years, it was used to hold both Republican and Democratic primaries.

A second incline was built in Price Hill by William Price, the son of General Rees E. Price, who had developed the neighborhood originally known as Price's Hill. The Price Hill Incline Railroad opened on July 14, 1875, starting at West Eighth Street and Glenway Avenue and rising 350 feet at a fifty-degree grade to West Eighth and Matson Avenue on top of the hill. The Price Hill Incline was a tremendous boon for the community, attracting new residents who could more easily traverse the hill in the enclosed passenger cars. A second pair of incline tracks exclusively for freight was added in 1877. Most of the inclines had a resort, but the Price Hill House was the only one that didn't serve alcohol because William Price objected to it. That branded Price Hill with the nickname Buttermilk Mountain. The Price Hill House burned twice and both times was rebuilt, yet the pavilion lasted until 1938 and closed a few years before the incline did.

The Mount Adams and Eden Park Inclined Plane Railway opened on March 8, 1876, giving access to both the hilltop neighborhood and the popular park. The incline resorts were similar in design to seaside resorts, with bay windows and verandas to take advantage of the venue. The Highland House by architect George W. Rapp, with its Victorian features and turreted towers, was an immensely popular venue, featuring operas, concerts and lively amusements, though it lasted just twenty years. The Mount Adams Incline had the longest run and made it possible for the Cincinnati Art Museum and Rookwood Pottery to be located on the hill.

The same year, a fourth incline was added at Elm Street and McMicken Avenue, leading up to Clifton with access to Burnet Woods, the Cincinnati Zoological Garden and, much later, the University of Cincinnati. The Cincinnati and Clifton Inclined Plane, better known as the Bellevue or Clifton Incline, opened on September 19, 1876. The same day was the grand opening of the Bellevue House, a grand resort designed by James W. McLaughlin with an attractive rotunda that seemed to hang over the edge of the hill.

The inclines had a relatively good safety record except for one tragic accident that claimed six lives. Just after noon on October 15, 1889, the car ascending the Mount Auburn Incline didn't stop at the top and went full speed into the station, shattering the windows. The engines kept turning,

causing the cables to pull free, and with nothing restraining the car, it plummeted down the incline to the bottom. As the car hit the lower shed, the roof broke from the car and flew into a grocery store at the base of the hill on Mulberry Street. The car was smashed into a mess of twisted metal, shattered timbers and mangled bodies. Six of the eight passengers were killed in the wreck: Judge William M. Dickson, Michael Kneiss, Mrs. Caleb Ives, Mary Errett, Jasper McFadden and Agnes Hochstetter. The other two passengers were severely injured.[23]

The remodeled incline reopened the next year, but passengers evidently were not reassured. Charles Kilgour purchased the Mount Auburn Incline in 1898 and closed it. The tracks were used for his street railways. The Lookout House had been derelict for several years before the resort was torn down in March 1894. Two weeks later, the opera house portion was destroyed in a fire.

All but the Price Hill Incline were eventually absorbed by the streetcar monopoly and made part of the streetcar routes. The passenger cars were replaced by platforms on which streetcars would park to be carried up and down the hills. The Cincinnati Street Railway Company built a fifth incline into Clifton that was made using mostly spare parts from the Bellevue Incline rebuild. The Fairview Incline opened on August 4, 1894. It was in line with where the Western Hills Viaduct lies, reaching up to Fairview Avenue. In 1901, the Cincinnati Traction Company leased all the property of the Cincinnati Street Railway Company, including the inclines (except for Price Hill). As far as the Traction Company was concerned, the inclines just slowed downed their traffic. But they were popular with passengers, so it was difficult to close them down. After the Fairview Incline was declared unsafe for streetcars, passengers hated having to transfer from streetcars to the incline cars and back, and the incline closed in 1924. Three years later, the Bellevue Incline was abandoned.

In October 1906, the cable snapped on the freight plane of the Price Hill Incline. The platform floor collapsed and dragged the platform to a stop before it hit the bottom, but the opposite platform jumped the track and smashed the operator's booth. No human lives were lost, but four maimed horses had to be put down. The freight plane closed in 1928. Price Hill's passenger line continued until 1943, when it, too, was abandoned despite an increase in ridership throughout the previous decade.

That left the Mount Adams Incline as the last, though it was also endangered. The city modernized transportation, and buses that could easily climb the hills replaced streetcars. (Streetcar service ended on April

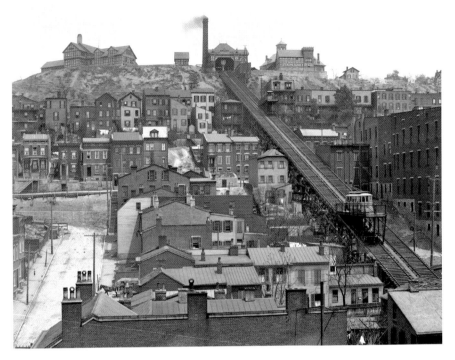

The Mount Adams Incline, the last of the inclines to close, was a popular attraction as well as an effective way to climb the hill. The Sterling Glass Company building replaced the Highland House in 1905. *Courtesy of the Library of Congress/Detroit Publishing Company.*

29, 1951.) The Mount Adams Incline carried its last bus on April 16, 1948, and was reportedly closed for repairs for a year, but it was never to operate again. The inclined plane was demolished in 1952, and the stations were torn down two years later.

Inclines provided a thrill beyond mere transportation. In addition to the amusement park factor, there were the incredible views of the city. In Pittsburgh, both the Monongahela and Duquesne Inclines, which date to the 1870s, are still in operation as tourist attractions. It seems neither likely nor feasible that Cincinnati could install new inclines. Price Hill has embraced its incline history, dubbing that section of East Price Hill the Incline District. In 2012, the Incline Public House restaurant opened on the site of the old Price Hill House (it does serve alcohol), with the spectacular view of the city basin one of its main attractions.

7

RAILROAD DEPOTS

U nion Terminal is justifiably one of the city's icons. The landmark half-dome façade is as identified with the Queen City as Fountain Square and the Roebling Suspension Bridge. The $41 million railroad complex was constructed during the height of the Great Depression in the age-defining Art Deco style. The timing was perfect, as it was funded before the economic depression hit and its construction was deemed necessary for nearly all parties. There had been need for a unified railroad terminal for decades. In the 1920s, downtown Cincinnati was served by five separate railroad depots spanning the eastern and western edges of town. This meant that a passenger needing to transfer to another railroad line had to traverse several city blocks, dragging luggage in tow, to another station. Not only was this awkward, but it was also embarrassing for a city with Cincinnati's industrial and commercial importance.

George Dent Crabbs, president of the Philip Carey Manufacturing Company, was placed in charge of building a terminal for all the passenger and freight railways in one location. The architectural firm of Alfred Fellheimer and Stewart Wagner of New York was hired to design the station and platforms, with Paul Cret of Philadelphia as supervising architect. The complex included twenty-two distinct buildings and ninety-four miles of track, but the most obvious and celebrated features were the passenger station, arcade and concourse, which is generally thought of as the terminal. The half dome, reminiscent of an old Crosley radio face, was the inspiration for the Hall of Justice in the Hanna-Barbera cartoon series *Super Friends*.

Inside, the rotunda is breathtaking, with its elegant arch lines and mosaic murals by Winold Reiss. It is doubtful that another civil structure with the same level of artistic elements, bold design and vast footprint could be constructed in the city today.

When Union Terminal opened on March 31, 1933, it marked a more efficient railroad system in Cincinnati. Though the change was welcome progress, it also meant the loss of the five old railroad stations it replaced, some of them attractive buildings in their own right. The Fourth Street and Court Street Stations were outdated and unremarkable, but the other three depots that vanished were torn down rather than repurposed in the manner of the Indianapolis Union Station, now a hotel, and Union Terminal, home to the Cincinnati Museum Center.

The oldest of the three depots was the CH&D Station, built for the Cincinnati, Hamilton & Dayton Railroad in 1864 at West Fifth and Hoadley Streets in the lower West End. Later, Baymiller Street extended south to be the corner at Fifth Street. The CH&D Station would become known as the Baymiller Street Station when CH&D was acquired by the Baltimore & Ohio Railroad (B&O) in 1917. At the time it was built, in the midst of the Civil War, the CH&D Station was considered an extravagant building costing $136,000. The headhouse, or station house, was two and a half stories tall with a corner clock tower that was another story and a half tall and topped with a mansard roof and cupola. The Byzantine brick structure was trimmed with stone and featured arch windows and two lofty arches at the Fifth Street entrance.

The Pennsylvania Station stood at Pearl and Butler Streets in the Bottoms district on the land where the Miami & Erie Canal had emptied into the Ohio River. Completed in 1881, the depot was known originally as the Pan Handle Station, named for the Pittsburgh, Cincinnati & St. Louis Railroad, more conveniently called the Pan Handle Railway Company. When the railroad merged with the Pennsylvania Line, the depot became the Pennsylvania Station. Architect S.J. Hall designed a Gothic Revival structure two stories tall, plus an attic, and a four-story-tall clock tower capped with a pyramidal roof that flared outward. The walls were red brick with freestone used for the base and details, and the station featured rows of closely grouped windows and second-story skylights. The platform system behind the headhouse was open except for a black-painted iron fence, thus offering an exciting street-view of the trains in the station but also allowing passengers to access the trains directly and bypass the station house.

The first station in Cincinnati to unite several rail lines in one place was the Central Union Depot, often known as Grand Central Depot, at West Third Street and Central Avenue, a block south of the Grand Hotel. The station that opened on April 9, 1883, was greatly scaled down from the grand design by Chicago architect William W. Boyington, who designed the Chicago Water Tower. Boyington's original design had been for a monumental $1 million station in the decorative Eastlake style, with three distinct but unified sections. The main building was to be five stories tall, with a corner clock tower another four stories above that whose mansard roof would be topped with a pyramidal spire. The wings for the waiting area and baggage would have been as ornately styled. *Railroad Gazette* called the plans "the largest and finest passenger depot in the West."[24] What was built instead was a four-story Victorian headhouse with considerably less ornamentation and no towers. The brick building had a high base of irregular stone and a mansard roof that was broken up with pedimented dormer windows. The waiting room, dining room, baggage area and concourse were crammed into one level, reducing accessibility for passengers. The train shed had a long segmented vault ceiling but was rather plain in appearance. The version of the Central

Central Union Depot, also known as Grand Central Depot, was the station for the Big Four railroads but closed along with the other depots when Union Terminal was built. *Courtesy of the Library of Congress/Detroit Publishing Company.*

Union Deport that was constructed was still handsome, but the proposed design would have been on par with Music Hall in its grandeur.

In 1889, several railroad companies, including those served at the Central Union Depot, merged to become the Cleveland, Cincinnati, Chicago and St. Louis Railway, commonly known as the Big Four. Central Union became a Big Four station for trains from all the major railroads to reach the East and South, including the Chesapeake & Ohio, the B&O and the Louisville & Nashville railways. Still, not all the lines were available there, and coupled with the flooding problem at the stations closer to the river, the building of Union Terminal was an improvement for the city.

All of the train depots closed once the rail lines relocated to Union Terminal. The closing of Central Union also precipitated the closing of the Grand Hotel. Within a couple years, all the other depots were gone. The location of the CH&D Station was cleared away as part of the Kenyon-Barr district that became Queensgate; the site is now between Freeman Avenue and Linn Street, south of the Sixth Street Expressway. The Pennsylvania Station site is near East Pete Rose Way at the entrance ramp to the L&N Bridge, also known as the Purple People Bridge. The western end of Third Street, including the intersection with Central Avenue, was cleared for the supports of the Third Street Viaduct section of Fort Washington Way. A portion of a wall from the lower level of the Central Union Depot still exists as the back wall of a parking lot below Third Street. The top of the wall includes a section of the building base, looking like half of a stone wall.[25]

LINCOLN PARK

Building Union Terminal also meant the loss of Lincoln Park, a picturesque oasis serving the West End neighborhood. In the early days of Cincinnati, what became Lincoln Park was the city's potter's field, a burial ground for the unknown, the abandoned and the poor. Grave robbing was a common practice to provide specimens for the medical colleges. The land was converted into a city park in 1858 and called Lincoln Park. Freeman Avenue and Kenner, Hoefer and Hopkins Streets formed its borders. The centerpiece of the park was a man-made lake for boating and fishing; it was frozen over for ice-skating during the winter. D.J. Kenny's description of Lincoln Park paints a beautiful image:

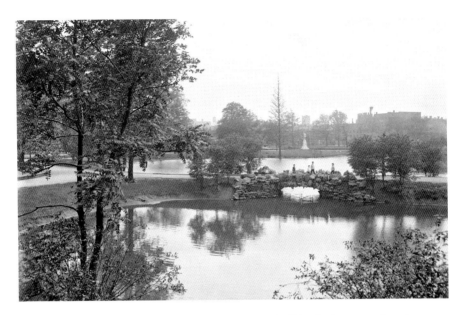

The lake and gardens of the picturesque Lincoln Park in the West End was remade as the esplanade leading to Union Terminal. *Courtesy of the Library of Congress/Detroit Publishing Company.*

The walks wind in and out of shade-trees, by green grass and beds of geranium and fuchsia and verbenas and other garden flowers bright with blossoms, and by the borders of the lake in the center, well-stocked with swan and rare foreign aquatic birds, with an island in the middle…

[W]ith the grotto and the lakes, the flowers and the aquatic fowls, and the birds fluttering upon the branches, with the hundreds of lights reflected in the waters, over which an occasional skiff glides, almost noiselessly, it often presents, in the early evening, a scene like fairy land.[26]

Lincoln Park had a ball field called Union Grounds that was used by the Union Cricket Club. For a couple seasons in the 1860s, it was also the home field of the Cincinnati Base Ball Club, the forerunner of the Reds.

The location chosen to build the depot was a lot of 287 acres east of Freeman Street, and the design called for Lincoln Park to be completely remodeled as an appealing entrance for automobile traffic to approach the terminal. The design of the park space is in harmony with the Art Deco Union Terminal as a long strip of trimmed lawn leading to a fountain. Most of that greenspace, at the time still identified as Lincoln Park, has since been filled with parking lots on either side of the grass strip. Compared to the lush park it was before Union Terminal, though, it is merely pleasant landscaping.

Union Terminal Concourse

During World War II, the Union Terminal concourse was the last view of home for thousands of GIs shipping out to war, and it was a welcome sight to those who came home again. The highway system and airline service drastically cut into passenger rail use in the United States starting in the 1950s, and Union Terminal was eventually forced to cease train operations. The last passenger train left the station on October 28, 1972. Amtrak returned to Union Terminal in 1991 for limited operations three times a week, but by then the concourse was long gone.

The terminal building, for all its admirers, is expensive to maintain, and in the 1970s, it was viewed as derelict. There was a fight to save the building from destruction, with promises of using it for other purposes, but without daily use, it was too big. The concourse could not be saved.

The concourse was a long corridor stretching back from the rotunda to the tracks, serving as the waiting area for the arrivals and departures.

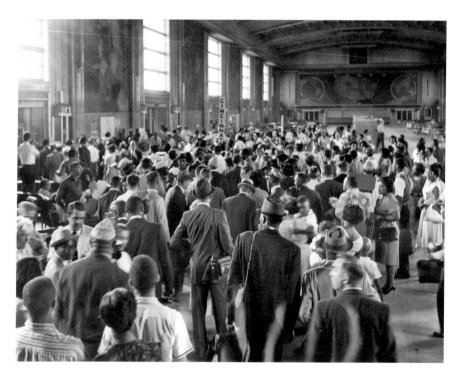

Passengers wait in the Union Terminal concourse to board a train on August 27, 1963, to join the March on Washington where Reverend Dr. Martin Luther King Jr. gave his "I Have a Dream" speech. *Courtesy of the* Cincinnati Enquirer/*Fred Straub.*

Semicircles of leather-covered lounge seats were interspersed between the gates. Union Terminal's walls were adorned throughout with twenty-three murals by Reiss, a German immigrant and famed Art Deco muralist. The two murals on the curved rotunda walls depicting a timeline of the region in figures and modes of transportation are some of Union Terminal's most celebrated features. Fourteen of the concourse murals show scenes of Cincinnati's leading industries at the time the terminal was constructed, including Procter & Gamble, Rookwood Pottery, Baldwin Piano Company, E. Kahn's & Sons Company, Cincinnati Milling Machine Company and WLW/Crosley Corporation. In June 1974, each of those enormous murals—twenty feet tall, twenty feet wide and eight inches thick, weighing eight tons apiece—was loaded onto a semi truck and driven across the river to be installed in the terminals of the Cincinnati/Northern Kentucky International Airport. No one stepped up to save the last mural, a wall-sized map of the United States. It was demolished along with the concourse. The *Enquirer*'s Cliff Radel described the lost mural:

> *Silver slivers of colored glass marked the states' borders. In the daylight and at night, the silver glistened like flowing streams of mercury. The states glowed with different hues of earth-tone tinted mortar. Major cities were spelled out in the terminal's specifically designed art-deco typeface. The largest letters went to "Cincinnati."*
>
> *Five mosaic representational clocks marked the map's five time zones… The map mural also featured smaller world maps. North and South America stood on the left. Europe, Asia and Africa occupied the right side…*
>
> *And, then, with one swing of a wrecking ball, the mural was gone. Forever. A priceless work of art smashed.*[27]

As of this writing, the murals are endangered once again. Two of the airport terminals are set to close in 2015, and efforts are being rallied to save nine of the industrial murals once again, with the Duke Energy Convention Center cited as their most likely destination. An ArtWorks mural depicting close-ups of the hands from Reiss's industrial murals was painted on the exterior of the convention center, perhaps a harbinger of their future home.

Part III
ENTERTAINMENT

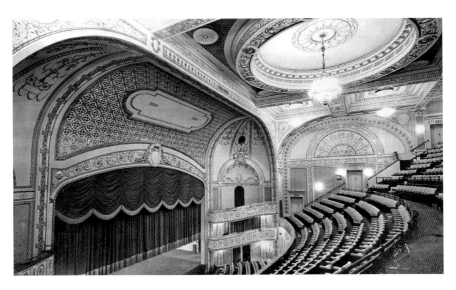

The interior of the Shubert Theater underwent an extensive remodel in 1964. *Courtesy of the* Cincinnati Enquirer/*Mark Treitel.*

8

THE BREWERY DISTRICT

The first documented brewery in the city was opened by Davis Embree at 75 Water Street near Main Street in January 1812. The earliest breweries in Cincinnati were small affairs owned by English and Scottish settlers who brewed ales, porters and common dark beer. In the 1840s, German immigrants flooded Cincinnati, settling north of the Miami & Erie Canal, which they called "the Rhine" in reference to their homeland river. Thanks to this influx, the city's population more than doubled; by 1850, Cincinnati was the sixth-largest city in the United States and the largest in the West. More than that, the city's identity was molded in this crucial period, particularly with its German Catholic heritage and the burgeoning brewing industry.

Beer was part of the German identity, and it wasn't long before enterprising immigrants started brewing their own European-style beers. Back in the Germanic states, brewers had been experimenting with yeast to make a lighter lager beer, and it was introduced in America in the early 1840s. Lager needed to be kept cool during the summer months, so the first lager breweries were built abutting the Clifton hills along McMicken Avenue, where cellars and tunnels could be bored into the hillsides. State law didn't allow brewing and bottling in the same facilities, so some breweries used tunnels beneath the streets to connect their buildings. Over-the-Rhine became more than the German district; it was the brewery district. Many larger breweries built plants near the canal, which they used for transporting barley and grain from farms up in West Chester.

Germans weren't the only ones imbibing. All of Cincinnati loved beer. In 1879, a *Cincinnati Commercial* reporter collected remarkable stories of the vast beer consumption of Cincinnatians. Some men claimed to quaff enormous quantities in one sitting, with the brewery employees the "best customers," limited by company regulations to around twenty-five glasses per day on the job. The reporter added, "Some of them tell marvelous stories of the number of times they drink a day."[28]

In 1893, the city boasted 2,091 saloons—that comes to about one saloon for every forty adult males in town.[29] A saloon could be as simple as a room with a bar or as elaborate as a beer garden. The largest and most popular beer garden in Over-the-Rhine was Wielert's Café and Pavilion at 1406–1412 Vine Street, started by Henry Wielert about 1867. Behind the building was a long hall with a roof, no walls and rows and rows of tables. Conductor Michael Brand regularly led concerts there with the Cincinnati Orchestra Reed Band that would become the nucleus of the Cincinnati Symphony Orchestra. It was well known that Boss Cox, the political boss of Cincinnati, used Wielert's as his headquarters and met with his associates at his personal table. The old building still stands vacant near the Kroger on Vine Street.

The country's indulgence gave rise to the temperance movement, which advocated moderate consumption of alcohol or its outright elimination. The Anti-Saloon League succeeded in convincing Congress to pass the Eighteenth Amendment, which banned the manufacture, transport and sale of alcohol. Prohibition went into effect on January 17, 1920, and the entire country went dry. Many of the Cincinnati breweries switched to producing cereal-based beverages called near beer or soft drinks, such as root beer and ginger ale, while others ceased production completely. Before Prohibition, there were sixteen breweries in Cincinnati, but only three lasted until Prohibition was repealed with the Twenty-first Amendment in 1933. A few local companies then started brewing, but the city's largest breweries never opened again.

CHRISTIAN MOERLEIN BREWING CO.

The biggest name in Cincinnati's brewing history was Christian Moerlein, a Bavarian immigrant who arrived penniless and built one of the largest breweries in the United States. A blacksmith by trade, Moerlein recognized the demand for beer among Germans in Over-the-Rhine and

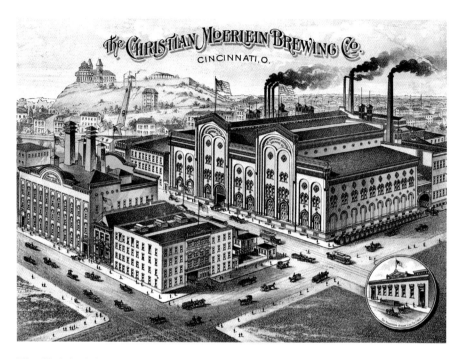

The Christian Moerlein Brewing Company was a huge complex on Elm Street. The Bellevue Incline and Bellevue House are pictured in the background. *Courtesy of the Cincinnati Enquirer archives.*

knew he could be more profitable as a brewer. He partnered with Adam Dillmann in 1853 to start a small brewery in the back of his blacksmith shop. Dillmann died the next year, so Moerlein hired Conrad Windisch. They started brewing lager. Windisch sold his shares of the company in 1866 to branch out with his own brewery, which would become Christian Moerlein's biggest rival.

In 1868, Moerlein built an expansive brew house at Elm and Henry Streets that was three stories high and divided into five sections. The architectural style was called Rundbogenstil, a variety of Romanesque Revival with rounded arch "eyebrows" over the windows. The gables read "Elm St. Brewery" and "C. Moerlein" in English and German. Christian Moerlein was already Ohio's largest brewery when business exploded thanks to sly marketing. The Centennial International Exhibition held in Philadelphia in 1876 was the first World's Fair in the United States. It attracted nine million visitors, nearly 20 percent of the U.S. population at the time. Moerlein's son George made an extravagant display for the exhibition that had statues of historical figures and moving parts, all to get the Christian Moerlein name on everyone's lips.

It worked, and sales skyrocketed. Soon, the brewery's National Export and Barbarossa brands reached nearly every major city, even overseas.

When Christian Moerlein died in 1897, his brewery was one of the top ten in the nation, producing 500,000 barrels a year. But when Prohibition hit, the family decided the brewery would not be profitable and closed it down in 1919. Though the brewery was razed in 1947, the majority of the plant exists today.

LION BREWERY

Conrad Windisch left Christian Moerlein in 1866 and formed a partnership with brothers Gottlieb and Heinrich Muhlhauser to start their own brewery. The Windisch-Muhlhauser Brewing Company built an impressive red brick Romanesque Revival brewery on the west side of Plum Street, facing the canal, between Liberty and Wade Streets. Perched atop the gables were two concrete lions, giving the plant the popular nickname the Lion Brewery. They utilized double-vaulted two-story cellars to keep their barrels cool and never upgraded to a refrigeration system. A George W. Rapp–designed gray Victorian brew house was added in 1888, though it didn't fit the Romanesque style of the main buildings. The company remained in the family after the deaths of the founders, but Windisch-Muhlhauser was unable to survive Prohibition, and the brewery closed in 1922.

The Bürger Brewing Company reopened the Lion Brewery in 1934. Burger (having dropped the umlaut because of backlash against Germans during World War II) was known for sponsoring the Cincinnati Reds radio broadcasts in the 1950s when sportscaster Waite Hoyt, a Hall of Fame pitcher, regularly plugged the beer on the air and announced home runs hit into Crosley Field's Sun Deck as "hit into Burgerville!" Burger closed in 1973, and the power plant, brew house and smokestack were torn down in the mid-1980s. The main plant was demolished in 1993. The next year, the Cincinnati Ballet built a new performance venue on the site. The ballet company even utilizes the old beer cellars to keep its costumes preserved.

The Lion Brewery's concrete lions, Leo and Leona, were spared the building's fate when it was discovered in 1952 that they were just sitting on concrete slabs, not attached to the building. Instead of being secured, the lions were removed. Leo's whereabouts are unknown, but Leona guards the entrance of an excavation company on North Bend Road.

ENTERTAINMENT

Dayton Street Brewery

John Hauck partnered with John Ulrich Windisch, a distant relative and brother-in-law of Conrad Windisch, to start the Dayton Street Brewery in 1863. As they found success, they built a three-story brewery on Dayton Street, completed in 1871. Built in the Romanesque Revival style common for breweries during that period, it was highlighted by an arched parapet with a clock in the center. When Windisch passed away in 1879, Hauck purchased his shares for $550,000, an astounding figure that was the largest recorded transaction in Hamilton County up until that time. It then became the John Hauck Brewing Company.

Under Hauck's ownership, the brewery was the third largest in the city, with Golden Eagle its most popular brand. Saloons usually served only one brewery's brands, and Hauck was the beer of choice at Wielert's Café as well as Hauck's own Washington Platform, which is still in business. The brewery was hit hard by Prohibition, though it outlasted many competitors

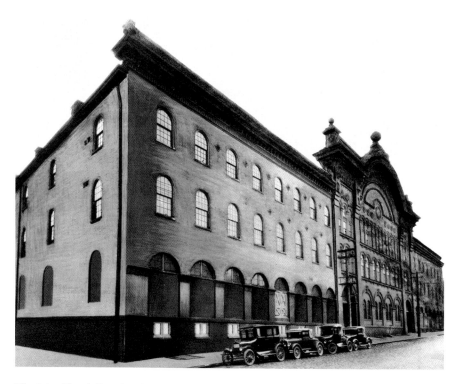

The John Hauck Brewing Company started as the Dayton Street Brewery. *Courtesy of the Cincinnati Enquirer.*

by selling Green Label near beer. The company closed in 1927 and dumped its vats into the sewer. Hauck, who died in 1896, left another legacy when he purchased the Cincinnati Zoological Garden and paid its debts during the zoo's financial struggles upon the death of founder Andrew Erkenbrecher in 1885.

The Red Top Brewing Company purchased the Hauck brewery in 1933 but closed the outdated plant in 1955. The brewery and brew house were razed, but the ice plant lasted until the 1990s. The Hauck office building, bottling plants and shipping warehouse still stand in the West End. The John Hauck House is a beautifully preserved Italianate residence in the Dayton Street Historic District and, for a time, was open as a museum.

Microbrews are helping Cincinnati's brewing district make a comeback, and the new breed of breweries is tapping into the city's brewing history. Greg Hardman purchased the Christian Moerlein brand in 2004, then added other defunct Cincinnati heritage brands like Hudepohl and Burger and began brewing them again in an Over-the-Rhine brewery. Hardman also runs the Moerlein Lager House brewpub on the Banks. The old Christian Moerlein bottling plant has been resurrected for Rhinegeist, a craft brew whose name translates as "ghost of the Rhine." Tours of the remnants of the pre-Prohibition breweries and the lager cellars and tunnels are often sold out. The whole Over-the-Rhine neighborhood is undergoing revitalization as a hotspot for restaurants, bars and urban living—not so much an echo as an encore.

9
ALBEE THEATER

Once upon a time, downtown had a number of palatial theaters, from opera houses to cinemas. None were finer than the Albee, located at 13 East Fifth Street, directly across from Fountain Square. Like nearly all the other downtown theaters, it is now gone. Only the Taft Theater, three blocks east on Fifth, is still around. The Albee Theater is legendary in Cincinnati. It is often sited as the prime example of the shortsightedness of the city's urban renewal. Although valiant efforts were made to save the Albee, time marched on without it.

The Albee was located in the heart of downtown and was one of the last of the city's grand theaters built, completed in 1927. Unlike most other theaters, which were converted from vaudeville stages to show movies, the Albee was built primarily to show films, along with some theater acts, though it was designed with the opulence of the opera houses of old.

The half block at the southeast corner of Fifth and Vine Streets was known as the Wiggins Block, after former owner Samuel Wiggins. The theater, originally to be called Fountain Theater, was built in conjunction with the Fountain Square Hotel, an eleven-story hotel around the corner on Vine Street, for a combined cost of $4 million.[30] Named for E.F. Albee, a vaudeville theater owner and the adoptive grandfather of playwright Edward Albee, the new theater would be the jewel in the Keith-Albee-Harris-Libson-Heldingsfeld chain, a complicated partnership that had been forged between the top names in theaters.

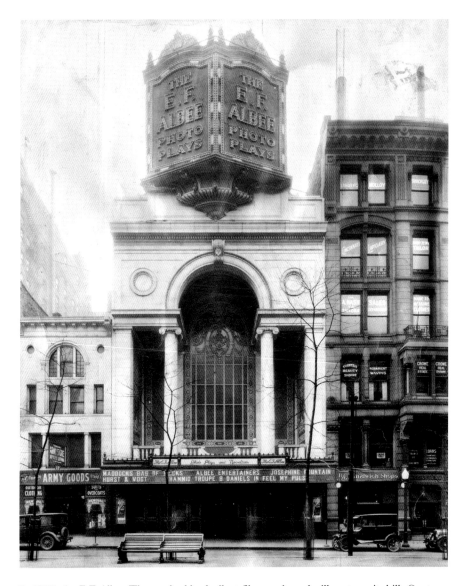

In 1928, the E.F. Albee Theater had both silent films and vaudeville acts on its bill. *Courtesy of the* Cincinnati Enquirer/*Harry Pence.*

In the 1920s, Thomas W. Lamb was the country's premier architect of movie theater palaces, from the Capitol in New York City to the Fox Theatre in San Francisco (both demolished) and the B.F. Keith Memorial Theatre, now the Boston Opera House, as well as the two most magnificent theaters in Ohio—the Ohio Theatre in Columbus and the Albee.

ENTERTAINMENT

The Albee, nestled beside the Hotel Gibson to the east and the Ingalls Building to the south, was deceptively large. The façade was notable for the mammoth Neoclassical marble arch looking like it belonged to another age. The arch was capped with an enormous sign showing "The E.F. Albee Photo Plays." "The exterior of the building gives no idea of the vastness of the theater's interior," the *Enquirer* wrote, adding, "The lobby, foyer and corridors of the New Albee seem more like the sumptuous quarters of a millionaire's club than a playhouse for the people."[31] Lamb drew on styles of the past, and the massive size and elegance was intended to overwhelm the patrons. The interior design was influenced by the Adams style, done by late eighteenth-century Neoclassical architect brothers Robert and John Adams.[32] The décor included lamps purchased from the home of John Jacob Astor for $5,000 and one-story-high etched mirrors costing $10,000 apiece. Paintings displayed along the mezzanine could have been in a gallery. Six floors of rooms—from a French ladies' drawing room to an English club–style men's lounge, all accessible by elevator—made the theater nearly a small hotel. Those impressed by the lobby and mezzanine were overcome when they ascended one of the twin marble staircases and entered the cavernous auditorium, which was five stories tall, seated four thousand and was decked out as a true palace. Intricate Rococo styling covered every surface, from the walls and ceiling to the balcony and boxes. The acoustics were superb, and no pillars obscured the sightlines, giving every patron an excellent view of the stage. A movable orchestra pit raised the musicians to stage level when needed. And all of it was just for watching movies. Frank Aston of the *Cincinnati Post* wrote, "What constitutes the stage show at the splendiferous new Albee probably doesn't interest you one bit. What you wish to see is the house."[33]

One of the most celebrated features was the Mighty Wurlitzer organ built to accompany silent films. The Rudolph Wurlitzer Company was started in Cincinnati in 1856, first importing musical instruments and then making pianos and organs. The Mighty Wurlitzer, made for use in theaters, was the company's most famous product. The Albee Wurlitzer was an Opus 1680, a three-manual, nineteen-rank Style 260 Special, one of only sixty-two made.[34] The organ pipes were installed in chambers on either side of the stage proscenium, behind grills above the boxes. The console was on a lift on the left side of the stage. When the Albee was under construction, no one knew the silent era of film was endangered, and then Al Jolson's *The Jazz Singer* introduced sound to the cinema in October 1927. The Albee Mighty Wurlitzer would play for only a little over a decade before it was mostly forgotten.

The E.F. Albee Theater opened on Christmas Eve 1927. Following the trend at the time, it was not a formal affair, although stars Gloria

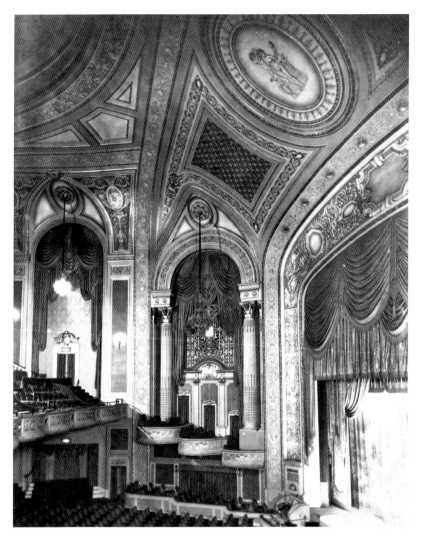

The Albee's opulent five-story-tall auditorium had no pillars to obstruct the view. The Mighty Wurlitzer is next to the stage. *Courtesy of Cincinnati Museum Center– Cincinnati History Library and Archives/W.T. Myers.*

Swanson, Harold Lloyd and Norma Talmadge wired their congratulations. Opening day featured *Get Your Man* starring Clara Bow, the "It" Girl, on the screen, accompanied by Cincinnati native Hy C. Geis on the organ, with live entertainment on the stage—all for seventy-five cents in the box seats.

In 1930, Ike Libson sold his theater interests, including the Albee, to RKO. The theater would be known as the RKO Albee Theater for

much of its existence. Vaudeville acts ended there in 1933, though stage shows continued until about 1960, with stars Fred Astaire, Jackie Gleason, Jack Benny and Benny Goodman making appearances on stage. It was occasionally used for rock concerts as well. Throughout the years, the RKO Albee was the grandest of the movie houses, making any film shown there special. Folks gussied up to go to the Albee. That experience is partly why the theater was so remembered.

As television encroached on movies' audiences and people moved out to the suburbs, the movie experience became less of a draw to come all the way downtown. All of the urban movie theaters suffered and were closed down one by one. Even the Albee appeared a bit tired with the brass fixtures painted gold to save on polishing. In 1972, as "one of the country's few remaining theaters built during the period of opulent cinema palaces,"[35] the Albee was added to the National Register of Historic Places. Then, after a showing of the Angie Dickinson exploitation film *Big Bad Mama*, the historic Albee closed on September 17, 1974.

City developers wanted to build around the city center, and the Albee was sitting on the most coveted real estate in downtown Cincinnati. Plans for a skyscraper on the site even considered folding the Albee into the new build, but that would add another $1 million to the cost. The idea was discarded. Frances Vitali, the owner of a Corryville laundry, took it upon herself to collect signatures to protest the demolition of the Albee and helped form the Save the Albee Committee, which rallied folks, including city councilman David Mann, who were interested in preserving the city's architectural heritage. Not everyone had such fond memories of the Albee, however. Black patrons had not been allowed into the theater until 1940 and even then only in the balcony. William Lawless Jones, an African American, wrote an opinion in the *Enquirer Magazine* in regards to segregation in the city's theaters:

> *Tear it down! I'm talking about the Albee Theater, and I repeat, "Tear it down!"…*
>
> *So I say to those people who want to preserve the Albee: Forget it! Forget it, because all it is to the black people of this now progressive city is a painful reminder of the time when they were second-class citizens deemed unfit to sit down beside someone…who happened to be classified as white.*[36]

A three-to-three tie vote by the City Planning Commission to include the Albee as a landmark under the city's "listed properties" finally doomed the theater.

In 1968, RKO sold off its theater organs, and the Ohio Valley Chapter of the American Theater Organ Society (ATOS) purchased the Albee Mighty Wurlitzer for one dollar. The chapter worked with the Ohio College of Applied Science–Ohio Mechanics Institute (OCAS-OMI), part of the University of Cincinnati, to relocate the treasured organ to the Emery Theatre in the OMI building at Walnut Street and Central Parkway. The Emery was closed for renovations in 1999 and has rarely been used since, so the Mighty Wurlitzer was moved to the Music Hall Ballroom in 2009.

The organ wasn't the only piece of the Albee saved. The theater's fixtures were put up for sale, with just about everything tagged, from the orchestra lift for $1,000 to theater seats for $20 apiece. Some components of the Albee live on in the Ohio Theatre in Columbus, which was in a similar situation but was saved from the wrecking ball in 1969 when supporters raised $2 million. Another of Lamb's designs, it easily incorporated the Albee's ornate brass doors, benches, ticket-taker posts and drinking fountain. When the wrecking crews finally came to the Albee in March 1977, workers carefully dismantled and labeled each marble piece of the façade arch and saved them for later use. For the 1986 renovation of the Convention Center, the Albee arch was affixed to the Fifth Street side of the modernist building. It is an awkward nod to the city's history because the architectural styles do not blend at all. Additionally, the location is not a very visible section of the Convention Center, so few people even know the arch is there. The Westin Hotel and U.S. Bank Tower now take up the entire stretch of Fifth Street between Vine and Walnut Streets. In the Westin atrium, where the Albee stood for fifty years, the historic theater's story is told on a wall display as a reminder of what was lost.

NATIONAL THEATER

The first grand theater in Cincinnati was the National Theater, one of the largest in the country in the days before the Civil War. The most distinguished actors and actresses of the day, from Junius Brutus Booth the elder to Jenny Lind, played the "Old Drury," a nickname the National Theater acquired for its comparisons to London's Drury Lane. With 2,500 seats, it was larger than its famous counterpart and was the city's most celebrated playhouse until Pike's Opera House opened in 1859.

The National Theater was built on the east side of Sycamore Street between Third and Fourth Streets and was completed by John Bates, an

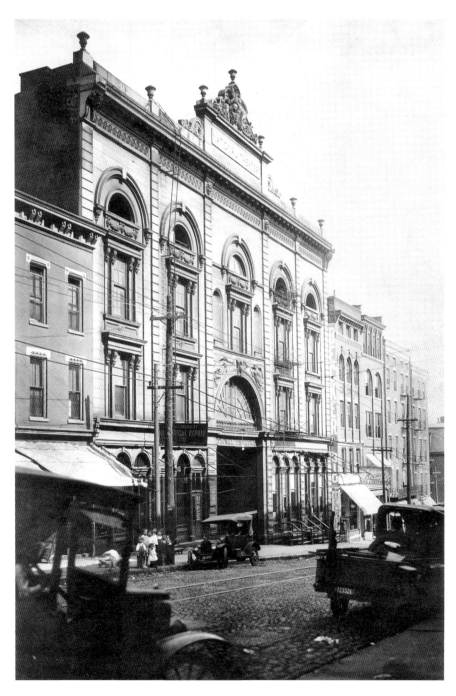

The National Theater was widely regarded as one of the finest theaters in the country. *Courtesy of the* Cincinnati Enquirer.

Englishman and owner of the Exchange Bank. Bates became synonymous with the National Theater and was regarded as one of the most successful theater managers in the West. The National Theater opened on July 3, 1837, to great fanfare. The four-story building was designed by Cincinnati architect Seneca Palmer, who designed the eclectic Trollope's Bazaar. John R. Hamilton remodeled the original plain brick front in 1857 as a decorative façade that became a landmark of the city's early theater days. The Spence brothers, tobacco manufacturers, bought the National Theater about 1881 for use as a tobacco warehouse, which it remained until the old landmark theater was razed in 1940 for a parking lot. Great American Tower at Queen City Plaza, the city's tallest building, now sits on the site.

GRAND OPERA HOUSE

The Grand Opera House building on the west side of Vine Street at Longworth (later Opera Place), north of Fifth Street, started as the Catholic Institute in 1860. The Roman-styled building had the figure of America holding a flag and shield standing above the entrance. There were saloons in the basement, a gymnasium and a great hall on the third floor that in 1863 was converted into Mozart Hall, a music hall seating three thousand. Industrialist David Sinton, the wealthiest man in Ohio, acquired the institute and transformed it into an opera house with a renovated Mozart Hall. The Grand Opera House opened on September 7, 1874, and for over a quarter of a century, it hosted the best actors and the most expensive productions in the Queen City. Theater architect John B. McElfatrick made radical improvements to the theater, and in 1885, Sinton converted Mozart Hall into a gym for the Cincinnati Gymnasium Association, which later built the Cincinnati Athletic Club. A few minutes into the show on January 22, 1901, a fire broke out off-stage. Within an hour, flames had consumed the building and caused considerable damage to the Ohio Mechanics' Institute next door, but no one was injured. Queen Victoria died the same day, so they shared the front pages.

The Grand Opera House was reconstructed with virtually the same façade, opening on September 15, 1902. The interior by William H. McElfatrick was showcased in *Architects' and Builders' Magazine*: "Wonders have been accomplished in replanning and redecorating the interior."[37] They praised the "free use of white marble," noting the unique marble rail at the rear of the auditorium and the marble staircases. The opera house

gave up legitimate theater in 1932 to be a first-run movie house, but it closed on July 20, 1939, and was replaced by the Grand Theater, a modern cinema designed by Drew Eberson. The Grand closed on March 19, 1975, and was wrecked. Today, the site is a JoS. A. Bank store.

FAMILY THEATER

The Family Theater had many identities. The four-story building at 520–528 Vine Street, between Fifth and Sixth Streets, opened on January 1, 1878, as the Florentine Hotel and restaurant. In 1883, the hotel was transformed into a dime museum, a popular attraction in cities at the time, where patrons could catch a glimpse of curiosities like Joe-Joe the dog-faced boy and the "Armless Wonder" for just ten cents. The dime museum operated for nearly two decades under several names and owners but was mostly known as the Vine Street Dime Museum. Winsor McCay designed posters for the museum before becoming a cartoonist at the *Commercial* and then at the *Enquirer*. McCay went on to create the innovative comic strip *Little Nemo in Slumberland* and was an animation pioneer with his short film *Gertie the Dinosaur*.

The museum was converted into the Majestic Café for a few years before the Cincinnati Family Theater and Amusement Company leased the building, and a "complete new structure, from cellar to roof"[38] was erected as a 1,200-seat vaudeville theater, although the façade remained as it was. The Family Theater opened on February 20, 1911, and switched to showing films in 1915. The second-run movie house became the Western Theater in 1949. When its neighbor the Lyric was demolished in 1953, the Western Theater briefly became the New Lyric Theater to capitalize on the name, but it didn't last. The theater closed on November 25, 1955, and was torn down. The site on Fountain Square is currently a Chipotle restaurant.

SHUBERT THEATER AND COX THEATRE

The Shubert and the Cox, though separate buildings, were connected from their openings in 1921 until they were demolished in 1976. The Shubert building, at the northwest corner of Seventh and Walnut Streets, was built thirty years earlier. The castle-like stone structure was built for the Young Men's

Christian Association, or YMCA. The design, by James W. McLaughlin, used rough-hewn stone, window arches and a rounded corner tower capped with a conical turret—elements that were reminiscent of Richardson's Chamber of Commerce Building. The YMCA building opened on November 22, 1891, and was praised as "remarkable for beauty both inside and out."[39] But twenty-three years later, the building once "regarded as one of the finest, best and safest

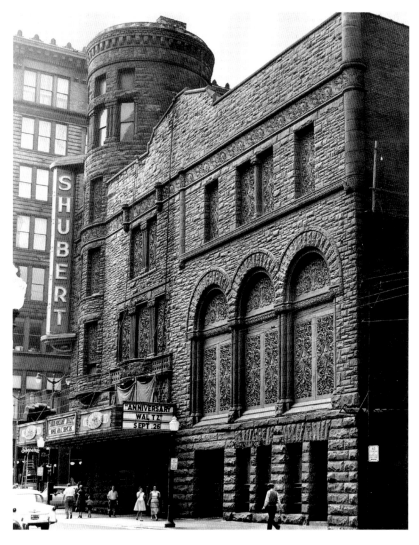

By 1956, the Shubert Theater, shown here from Walnut Street, had been stripped of the turret and gables from its days as the YMCA building. *Courtesy of the* Cincinnati Enquirer/*Herb Heise.*

buildings in Cincinnati"[40] was condemned by the commissioner of buildings, who said it would have to be remodeled.

In 1920, the Shubert Theatrical Company spent $1 million to construct theaters on Seventh Street. The YMCA building was converted into the Sam S. Shubert Theater, named for the Shubert brother killed in a train wreck in 1905. The gym floor was lifted at an angle for auditorium seating, the locker rooms were replaced with an orchestra pit and the stage was built over the swimming pool. Outside, the gables were removed and a vertical sign was added to the tower. After the turret was removed in 1946 for safety, the Shubert looked like a castle stripped of its armaments. The windows were eventually boarded up and adorned with decorative carvings. The 2,500-seat theater opened on September 25, 1921, to little fanfare. The second theater, abutting the Shubert at 36 East Seventh Street, was the George B. Cox Memorial Theatre, built by Caroline Cox, the widow of Boss Cox, who died in 1916. The foyer was done in elegant white and black marble, and medallions depicted Greek mythology figures throughout the 1,300-seat theater. The playhouse debuted on November 20 as a large affair befitting the name on the theater. President Warren G. Harding, a friend of Cox's, wrote a letter to express his regrets that he was unable to attend.

The Shubert eventually switched to showing movies, although the stage was still used at times. Duke Ellington played in 1935, and Laurel & Hardy performed in 1942. The Cox remained a playhouse all its days, but neither fared well as tastes in entertainment changed. In 1953, Reverend Earl Ivie leased the Shubert as his Revival Temple, but the Shubert reopened in 1955, with a renovation and the return of legitimate theater. The Cox, meanwhile, had its last production in 1954 and shut down. In later years, it was used to store props and equipment for the Shubert, which had another massive renovation in 1964. The interior was spruced up with fine detail, including a massive ceiling ornament around a one-ton crystal chandelier. Even that couldn't save the Shubert. The last performance was on March 23, 1975. The URS Center office building now stands at Seventh and Walnut Streets with CVS Pharmacy at the spot of the former Shubert's entrance.

GAYETY BURLESK THEATER

The Gayety Burlesk Theater, a strip club at 816 Vine Street, had as varied and complicated a history as any theater building in Cincinnati. Part of the building dated to about 1848 as the Vine Street Congregational Church. The

building was sold to the United Theaters Company in 1909 to be converted into a vaudeville playhouse. The Empress Theater opened on December 27, 1909. A 1,200-seat theater had been added to the church building, with fixtures in the Louis XV style and décor in orange and gold with green draperies ornamented in gold.

Fred Karno's Comedy Company, an English music hall troupe on the Sullivan-Considine vaudeville circuit, had four stops at the Empress in 1911 and 1912. The headliner was a young comedian named Charlie Chaplin. His understudy was Stan Jefferson, better known as Stan Laurel. Chaplin starred in the sketch "A Night in an English Music Hall" as the "souse," an old drunkard who disrupts the show from a private box. The Empress added "Burlesque" to its name in 1919, but burlesque at that time was a bawdier version of vaudeville that focused on humor. As burlesque became more risqué, the Empress followed suit; in July 1934, twelve underage girls were discovered to be employed in the chorus.

The Empress building had another claim to fame. On October 24, 1922, brothers Tom and John Kiradjieff, immigrants from Macedonia, rented the storefront in the theater building for their chili parlor, Empress Chili.[41] They introduced Cincinnati-style chili on coneys and chili with spaghetti, which have become culinary staples of the city.

In 1937, the Empress became the Gayety Burlesk (sometimes spelled Burlesque), which was a full-bore bump-and-grind club. Burlesque strip teases were tamer than the tawdry strip joints of the 1970s, and visiting the Gayety was something of a rite of passage for young males. Comedians from Red Skelton to Abbott and Costello shared the club with the likes of Rose La Rose. But by the late 1960s, it had become seedier, and "the Mistress of Vine Street" was set for demolition in 1970. King Wrecking Company hung up a sign: "Take it down…Take it all down!"[42] Many fond memories were made in that theater, so a two-night salute was held at the Shubert Theater, featuring a Harold Minksy revue. The event was a benefit for, of all things, WCET-TV, the local PBS station, and raised $25,000 for color television equipment. Then, the 122-year-old building—which had seen chili and Chaplin, sermons and sin—was gone. In 1982, the Main Library expanded on the site. The *Enquirer*'s Jim Rohrer noted, "So it's still a place where you could learn something."[43]

10

CROSLEY FIELD

O
f all the city's lost structures, Cincinnatians probably have the warmest feelings about Crosley Field. Certainly, there's the nostalgia factor among people who can still taste the brown spicy-hot mustard slathered on a hot dog or recall hopping off a streetcar at Western Avenue and buying a ticket for the Sun Deck. But Crosley Field is also regarded in the same pantheon of ballparks as Wrigley Field and Fenway Park, which were built in the same era. When Great American Ball Park was being planned, the loudest input from fans was to harken back to the days of Crosley.

The ball fields that the Cincinnati Reds played on during their first few years were a far cry from today's stadiums. The first games of the Cincinnati Base Ball Club, the forerunner of the Reds, were played on "the cricket grounds at the foot of Richmond street"[44] between Gest and West Eighth Streets in the old West End in 1866. Two years later, the club started playing at the Union Grounds, a cricket field owned by the Union Cricket Club that was adjacent to Lincoln Park, where the Union Terminal fountain is today. The club, by then known as the Red Stockings for its uniform socks, became the first professional baseball team in 1869 and went undefeated that season. In 1871, the Red Stockings moved to the Avenue Grounds near the stockyards along Spring Grove Avenue. The oblong field was nestled between railroad tracks and the Mill Creek at Arlington Street. They moved again in 1880 to the Bank Street Grounds on Bank Street, west of Western Avenue, but a rival league, the Union Association, wrested the ballpark lease away from the Reds, forcing the Reds to move again.

LEAGUE PARK AND THE PALACE OF THE FANS

Plans for a new ballpark at Findlay Street and Western Avenue were announced in December 1883, and despite the turmoil of the next few months, including the second-highest flood in Cincinnati history in February and the three bloody nights of the courthouse riots in March, the new grounds were ready for an exhibition game on April 9, 1884. But at the opening game on May 1, a small platform collapsed, and about fifty spectators tumbled to the ground. A few were injured, though there wasn't a fatality as is widely reported.[45] The ballpark had several names but was mostly known as League Park from when the Reds were part of the National League. That location would be the home of the Reds for the next eighty-six years. The original configuration of the field had home plate in the southeast corner of the lot, which meant the batters had to face into the sun in the afternoon. The field dimensions were lopsided as well because of the angle of Western Avenue. Ownership installed a new grandstand in 1894, and home plate was moved to the southwest section of the field, creating the orientation that would last through the Crosley Field days. A fire in May 1900 burned the iron and wood grandstand and half of the pavilion along the first-base line, but the Reds managed with a temporary grandstand and home plate briefly at its original position.

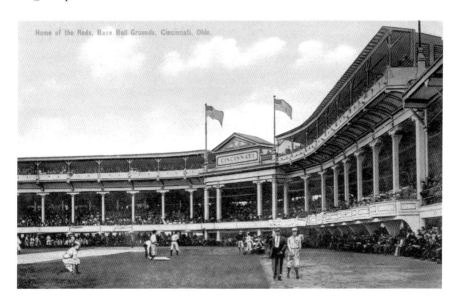

This postcard features the distinctive Palace of the Fans at the Reds' League Park. *From the Collection of the Public Library of Cincinnati and Hamilton County.*

The Reds decided on more than a remodel for the 1902 season and erected the Palace of the Fans, an elaborate grandstand that befitted baseball's growing popularity. The Palace of the Fans opened on April 17, 1902, and entered Reds lore as "the most distinctive grandstand ever built at a major league baseball park."[46] The stands behind home plate, possibly designed by Cincinnati architect Harry Hake,[47] blended Greek and Roman architectural elements, with twenty-two square columns supporting the roof. The centerpiece was an ornate triangular pediment with a stone etched with "Cincinnati," something akin to the façades of courthouses or theaters. Nineteen curved "fashion boxes" lined the front railing, extending over the field, while beneath the grandstand at field level were the cheaper seats known as "Rooter's Row." One drawback was the omission of dugouts—the players sat on benches in front of the stands. While this was considered by the team and baseball historians to be a new park, it used the old wooden stands from the previous seasons and technically was still called League Park. The Palace of the Fans name applied only to the grandstand.

REDLAND FIELD/CROSLEY FIELD

The Palace of the Fans, though elegant in appearance, proved inadequate for the sport's growth, and it was torn down after ten seasons. Hake was hired to build a modern concrete-and-steel ballpark at the same Findlay and Western location for a cost of $400,000. Hake would go on to have a distinguished career in Cincinnati as the architect of the Western & Southern Life Insurance Company building, the Queen City Club and the Cincinnati and Suburban Bell Telephone Company building. Hake drew up a new ballpark that wasn't as architecturally striking as its predecessor but made up for any lack with its accessibility to the fans. It was a working-class ballpark in a working-class neighborhood of warehouses and rail yards. The stands were intimate, affording fans proximity to the players. A boomerang-shaped double-decked grandstand behind home plate extended from third to first base, with single-level pavilions continuing to the outfield wall and the right field bleachers, for a total capacity of 26,336 seats. A trademark of the ballpark was the left-field terrace, a fifteen-degree incline near the fence caused by the expansion of the playing field onto street level at what was York Street. When the ballpark opened on April 11, 1912, the park had

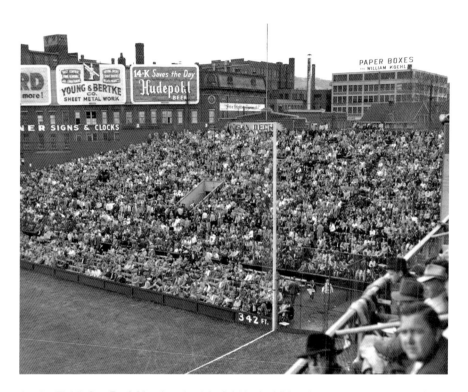

Crosley Field's Sun Deck bleachers in right field had additional seating known as the "Goat Run" in the 1950s. *Courtesy of the* Cincinnati Enquirer/*Herb Heise.*

yet to be named. Many favored naming it after Reds owner August "Garry" Herrmann, but he settled on Redland Field.

In 1919, the Reds fielded a pennant-winning team, and the city's first World Series game was played on October 1. Fans didn't know at the time that the fix was in, and several players on the Chicago White Sox team were bribed by gamblers to throw the series. The Redlegs triumphed in eight games in a best-of-nine series, but the championship was tainted by the "Black Sox" scandal when the fix was exposed and eight Sox players, including star "Shoeless" Joe Jackson, were banned from baseball for life.

Radio pioneer and Cincinnati entrepreneur Powel Crosley Jr. purchased the financially struggling Reds in 1934 in order to keep the team in town with local ownership. In gratitude, management pushed Crosley to rename the park after himself. Crosley Field underwent several modifications throughout the decade. The terrace was extended across the outfield, and a second deck was added to the pavilion seating. In 1938, home plate was moved twenty feet closer to the fences, making Crosley Field one of the

smallest ballparks in the country. Though the team reported the center-field fence at 383 feet, the players swear it was just 375 feet,[48] the shortest in the majors. On May 24, 1935, Crosley Field was the site of the first night game in major-league history. President Franklin D. Roosevelt flipped a switch in the White House that turned on 632 lamps atop eight metal light towers surrounding Crosley Field. It would take several years for the experiment of night baseball to catch on.

In January 1937, the Ohio River crested at a record eighty feet, leaving Crosley Field under twenty-one feet of water, but it was still ready for Opening Day a few months later. Crosley Field hosted two All-Star Games and five World Series. The Beatles played at Crosley on August 21, 1966. The 1950s were the ballpark's heyday. Popular landmarks of the era were the right-field bleachers, called the Sun Deck (or the Moon Deck for night games), the "Goat Run" seating addition that reduced the distance to right field to encourage more home runs and the scoreboard with the familiar Longines clock. The surrounding buildings were demolished for parking space, although there was never enough parking. New ballparks were then being designed not only with automobiles in mind but also for multiple sports.

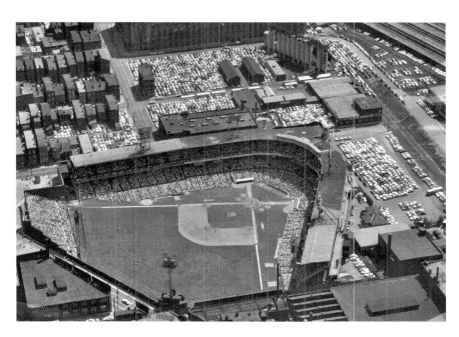

The warehouses around Crosley Field had been replaced by parking lots by 1956. *Courtesy of the* Cincinnati Enquirer/*Carl Wellinger.*

In 1967, Hall of Fame coach Paul Brown was granted a football franchise for Cincinnati in the American Football League with the understanding that the team would be part of the National Football League when the leagues merged in 1970. The Cincinnati Bengals, named for a short-lived professional team from 1937, played at the University of Cincinnati's Nippert Stadium until a new stadium could be built. Multipurpose stadiums were becoming standard. Baseball and football teams could share facilities to save expenses. So it was decided to build Riverfront Stadium along the banks of the Ohio River.

The final game at Crosley Field was played on June 24, 1970. Home plate was delivered by helicopter to the new stadium for the next home game. The city purchased the ballpark for $2.5 million and used it as a car impound lot. In April 1972, Crosley Field's fixtures were sold as memorabilia, and the wrecking ball came swinging. The ballpark was paved over as part of the Queensgate industrial complex, and Dalton Avenue was extended through what used to be right field.

Affection for Crosley Field hasn't faded over time. Two replicas of the classic ballpark have been built, one in Union, Kentucky (since demolished), and the other in Blue Ash, a Cincinnati suburb, using the original blueprints of the field and scoreboard.

Riverfront Stadium

The Reds debuted Riverfront Stadium on June 30, 1970. The plans for a stadium on the riverfront traced back to the *Cincinnati Metropolitan Master Plan* of 1948. Architectural firms Heery & Heery and Finch, Alexander, Barnes, Rothschild and Paschal (FABRAP) partnered to build Riverfront Stadium, with a seating capacity of more than fifty thousand, for $50 million. The round, "cookie-cutter" multisport stadiums like Pittsburgh's Three Rivers Stadium and Philadelphia's Veterans Stadium all looked alike—a white-rimmed bowl with removable seating to configure the AstroTurf for baseball or football. Instead, the attraction was the product on the field.

A few weeks after the opening, Cincinnati hosted the 1970 All-Star Game, and President Richard Nixon threw out the first pitch from the stands. (The National League won when Reds outfielder Pete Rose famously collided with catcher Ray Fosse at the plate for the game-winning run.) That season was the start of the Big Red Machine teams with Pete Rose, Johnny Bench, Joe Morgan

Riverfront Stadium had already hosted an All-Star Game and World Series before its first Opening Day, April 5, 1971. *Courtesy of the* Cincinnati Enquirer/*Bob Free.*

and Tony Perez, led by Sparky Anderson. Riverfront crowds witnessed Hank Aaron tie Babe Ruth's all-time home run record, Tom Browning's perfect game and Rose break Ty Cobb's hits records with number 4,192. Five World Series and two All-Star Games were played there. The Bengals' highlight was winning the Freezer Bowl, the AFC Championship Game on January 10, 1982, in negative nine–degree temperatures, with the wind chill making it feel like thirty-seven below, to reach their first Super Bowl.

There never was the affection for Riverfront that there was for Crosley. In 1996, the Cinergy Corporation purchased the naming rights, and the stadium officially became Cinergy Field, though most people refused to call it anything other than Riverfront. In the 1990s, the trend reversed and new, distinctive stadiums with enticing amenities were all the rage. Bengals owner Mike Brown threatened to move to another city if they didn't get a new stadium, and the taxpayers conceded, passing a half-cent sales increase in 1996 to fund Paul Brown Stadium, which opened on the west end of the riverfront in 2000. The Reds also got a new ballpark, squeezed between Cinergy Field and U.S. Bank Arena (the old Riverfront Coliseum). While that was under construction, a section of Cinergy's outfield stands were removed, a forty-foot black wall was added as a "batter's eye" and, without

football to deal with, real grass was installed for the first time. *Enquirer* baseball writer John Erardi noticed that the quirky configuration had added character to the bland stadium:

> *It's hard to believe it's the same place.*
>
> *The new Cinergy Field starts with the grass, moves out to the "Black Monster" (the forty-foot high center-field wall) and extends to the views of Mount Adams, the Ohio River and part of the downtown skyline. In between, above and around and through, are all sorts of nuances that figure to impact the game and enhance the fans' enjoyment.*
>
> *The enchantment lies in the same thing that made so many of the old ballparks like Crosley so great: they had to be designed that way because of the constraints of the street grid and the topography around them.*[49]

The final Reds game at the stadium was played on September 22, 2002. The implosion of Riverfront Stadium on December 29 was even televised. Great American Ball Park opened the next spring.

11

OLD CONEY ISLAND

When Walt Disney was planning Disneyland, he and his brother Roy visited amusement parks around the country to see how it was done. In June 1953, one of their first stops was to Cincinnati's Coney Island, considered the finest amusement park of its day. The park's cleanliness and beautiful landscaping impressed Disney. Coney president Edward L. Schott was then among the amusement park owners invited to Anaheim, California, to advise Disney on how to actually run a park, from cleaning up to traffic flow and ride capacity, as one of Disney's "dollar a year" vice-presidents. In the late 1960s, when the Taft Broadcasting Company, headquartered in Cincinnati, wanted to find a theme park to use the Hanna-Barbera cartoon characters it owned, it went to Roy Disney for advice, and he told them that the best amusement park was in their own backyard—Coney Island. Such was the reputation of "America's Favorite Amusement Park."

Coney Island wasn't planned; it evolved. The land ten miles east of downtown Cincinnati, nestled on the Ohio River, was an apple orchard when James Bell Parker purchased the twenty-acre parcel from the estate of his neighbor Thomas Whetstone for $2,500 in 1867. There, Parker built a home and grew fruits and nuts. Before long, neighbors started to ask permission to hold Sunday afternoon picnics in Parker's picturesque orchard, where they could watch the steamboats roll along the river. Parker's Grove was known far and wide as a terrific picnic spot, and soon steamboat captains were bringing boatloads of people from the city. Parker

added a picnic shelter, a dance platform and the first ride in the grove—a merry-go-round where riders sat on wooden horses suspended from the ceiling that swung out as the carousel was turned by a mule. Parker's Grove had become a resort, which was more than Parker had planned on. Controlling crowds was a problem, as was regular flooding, so in 1886, Parker sold the land to William F. McIntyre for $17,500. McIntyre and his partner, Jacob B. Hegler, were captains of the steamboats *Guiding Star* and *Thomas Sherlock*, which had made many excursions to Parker's Grove. They formed the Cincinnati Steamboat Company with the idea of transforming the resort into something grander.

That summer, they began advertising for what they called Ohio Grove, the New Coney Island of the West. The original Coney Island in Brooklyn, New York, already had a reputation as the "playground of the world," so McIntyre and Hegler likely wanted to conjure up that association. Ohio Grove opened on June 21, 1886. "A complete metamorphosis has taken place," the *Enquirer* noted. "Nature has done much to beautify the place, but the lavish expenditure of money has made the spot a veritable Eden."[50] One innovation was to have the steamboats make regularly scheduled trips from the Public Landing in Cincinnati out to Coney Island, regardless of how many passengers were aboard. This meant families could go to Coney when they wanted to instead of waiting for the boat to fill up. The steamboats made four trips daily for a fare of fifty cents that included park admission. The name Ohio Grove was inexplicably changed to Coney Island on August 1, 1886, perhaps because patrons were already using the name.

Levi "Lee" H. Brooks took control of Coney Island in 1888. He purchased more of the Whetstone property to create the artificial Lake Como, named after the famous lake in Italy, and acquired the gondolas used in the canal during the city's centennial. Many early attractions utilized Lake Como, such as the Shoot the Chutes, where a boat slid down a ramp to skip across the water, and the circle swing, a one-hundred-foot tower that whirled around wicker boats like those used with hot air balloons. That year, Albert Heinichen of Cincinnati brought a Ferris wheel–like ride to Coney,[51] five years before George Washington Gale Ferris Jr. debuted the Ferris wheel for the 1893 World Columbian Exposition in Chicago.

Brooks dreamed of a floating ballroom as an upgrade for the Coney Island route and commissioned the Cincinnati Marine Railway to construct a custom-designed steamboat for $80,000. The *Island Queen*

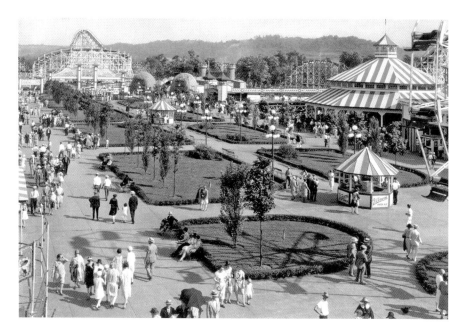

Guests spending the day at Coney Island in May 1928 could try the Wild Cat or Bluebeard's Castle or just stroll around the mall. *Courtesy of the* Cincinnati Enquirer/*Harry Pence.*

launched on May 16, 1896. The *Enquirer* called it a "floating palace"[52] and "in every respect the best excursion boat that ever was placed on the waters of the Ohio."[53] The *Princess* was added in 1905, and the two steamboats carried generations of passengers to Coney. The hour-long cruise was as much a part of the patrons' relaxing day as the visit to the park. The *Princess* was sunk by an ice floe in 1918 and was replaced by the *Morning Star*. On November 4, 1922, the *Island Queen* and the *Morning Star* were docked at the Public Landing when a pot of roofing tar was overturned on the *Star* and the wood caught fire. The flames spread to the *Island Queen* and two other boats tied up nearby; all four were destroyed. Insurance was insufficient to rebuild, and that prompted the Brooks family to sell the resort.

New owners Rudolph Hynicka (one of Boss Cox's lieutenants) and George F. Schott spent $1 million in 1924 to expand to 120 acres and build much of what is remembered about the park. They had a new *Island Queen* constructed at the Public Landing, costing $400,000. Its inaugural trip to Coney was on May 25, 1925. The second *Island Queen* was even grander than its predecessor and became a beloved part of Cincinnati history.

That year also saw the debut of a dance hall, originally called Moonlight Dansant but known to millions of courting couples as Moonlite Gardens. The midway was updated as the mall, a grassy strip with attractions on both sides. New rides were added, including the Ferris wheel, Noah's Ark, Bluebeard's Castle, the Jack and Jill slide, the Tumble Bug, the Cascades (aka the Lost River) and the Wildcat, a roller coaster that replaced the old Dip the Dips to become one of Coney's most popular rides. But the biggest addition, one that was to become the resort's trademark attraction, was the Sunlite Pool. Designed by top swimming pool architect W.J. Lynch, the $500,000 pool was 401 feet long by 200 feet wide and contained 3.5 million gallons of water. The Sunlite Pool opened on May 22, 1925. A new gate with a stone lighthouse tower was added to the park entrance and still stands as a Coney Island landmark. The park also took on a cleaner image, with flowered landscaping and sanitary facilities that later impressed Walt Disney. Coney began using the slogan "America's Finest Amusement Park," adding, "This is not a slogan or a phrase; it is a fact."

Being so close to the river, flooding was a constant threat. The great flood in January 1937 put nearly the entire park underwater, and when the water receded, the park was in shambles, covered under piles of debris. The lumber for the Clipper, a wooden coaster under construction, was washed away. Despite the park's low attendance during the Great Depression, Edward Schott and Ralph Wachs, who had taken control of the park after George Schott died in 1935, decided to repair and rebuild. The Moonlite Gardens attracted top talent, including Louis Armstrong, Tommy Dorsey and Frank Sinatra. The Land of Oz, a kiddieland, gave the younger set their own rides and the chance to meet storybook characters like Mother Goose and Little Bo-Peep. In 1947, the Clipper was partially dismantled and reworked as the Shooting Star, the signature ride at Coney. The Shooting Star is considered the "grandfather of the Beast," as it was a precursor to Kings Island's famous wooden coaster.

After the 1947 season ended, the *Island Queen* traveled upriver to Pittsburgh for a few days. On September 9, the steamer was docked at Pittsburgh's Monongahela River Wharf, where crew worked on repairs between excursions. At 1:16 p.m., a welding torch set off an explosion, igniting the twenty thousand gallons of oil stored on board. "Suddenly there was a stunning ear-splitting explosion that shook the great pleasure craft from stern to stern," the *Pittsburgh Press* reported.[54] Witnesses at first feared it was an atomic bomb explosion. Crew members were blown into the water and scrambled to look for survivors. Of the more than fifty on board, nineteen

ENTERTAINMENT

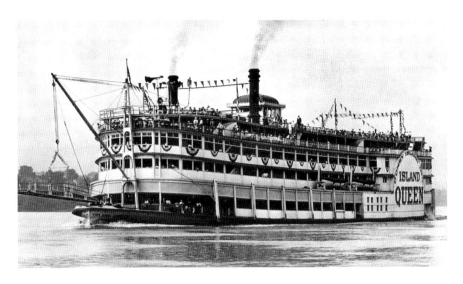

The second *Island Queen* ferrying guests from the Public Landing to Coney Island was a familiar sight during the summer. *Courtesy of the* Cincinnati Enquirer *archives.*

crew members were killed, and eighteen were wounded. Fire consumed the boat in ten minutes. The intense heat twisted the steel superstructure, and the skeletal hull settled into the muddy bottom of the Monongahela. "If ever there was a day that marked the end of an era in Cincinnati…it was the day the *Island Queen* died," the *Enquirer*'s Owen Findsen wrote years later. "The boat was what made Cincinnati summer special."[55]

The biggest blemish in Coney Island's history was not allowing African Americans admittance into the park until 1955. Boycotts and pressure from civil rights groups started making waves in 1952, but black patrons were turned away at the gate. When city councilman Theodore M. Berry, who later became the city's first African American mayor, voiced objections to the renewal of Coney Island's license, Coney president Edward Schott compromised with the NAACP to quietly permit blacks to enter the park but not the Sunlite Pool. The pool wasn't integrated until May 29, 1961.

The park was refreshed and updated in the 1960s under owner Ralph Wachs. The Wildcat was demolished in 1964 to make way for the Skyride, gondola-style cars that carried riders high above the mall. But competition with Cedar Point in Sandusky, Ohio, was starting to make a dent in attendance, and yet another flood in 1964 had the owners thinking of relocating the park. Then, in 1968, actor Fess Parker, who portrayed Davy Crockett and Daniel Boone on TV, announced plans to build Frontier Worlds, a $13.5 million amusement park, in Boone County,

Kentucky, just across the river from Cincinnati. Charles Sawyer, chairman of the board at Coney, sent a letter to Parker to discuss being competition for each other, but the actor didn't respond. Offended by Parker's brush off, Sawyer was more receptive to Taft Broadcasting chairman Charles Mechem, who suggested that Taft merge with Coney in a venture to build a new park in Warren County. Together they purchased 1,200 acres near Kings Mill, Ohio, about twenty-five miles northeast of Cincinnati, along Interstate 71, for $3.2 million. Plans for the new park were announced on March 28, 1969, and Parker's Frontier Worlds was doomed. Taft then acquired the assets of Coney Island, Inc., from the Wachs family for $6.5 million in Taft common stock. Coney Island would close, and the new $20 million park, originally called "new Coney" in early news reports, would open in 1972. The name Kings Island was chosen to reflect Kings Mills and to honor its predecessor.

In 1971, Coney Island's final season was advertised as a chance to say goodbye. After eighty-five summers, Coney Island closed its gates on Labor Day, September 6, 1971. *Enquirer* theater critic Tom McElfresh wrote a fitting sendoff:

> *If the fates were to be properly served—then this…epitaph should be blazed in fireworks across a sable-dark sky, or better still penned in sparkle dust on the dreams of a child.*
>
> *Coney Island. What wonders the name invokes. For a child. What garish, gaudy, boundless, nameless pleasures. The delights that coursed through Kubla Khan on contemplation of that stately pleasure dome Xanadu pale in the light of one kid's smile at mention of the magic name: Coney.*[56]

Many of Coney's rides, including the Grand Carousel, Skyride, Log Flume, Turnpike, Galaxi (as Bavarian Beetle), Flying Scooter (as Flying Eagles), Tumble Bug, Dodgem bumper cars, Cuddle Up, Monster, Rotor, Scrambler and Spider, were relocated to Kings Island.[57] There was discussion of moving the Shooting Star as well, but Kings Island opted to build a new twin-track roller coaster, the Racer, and the Shooting Star was razed. Instead, Canada's Wonderland, a sister park built outside Toronto in 1981, based its roller coaster Mighty Canadian Minebuster on the Shooting Star and the Wild Beast on the Wildcat. Kings Island held its grand opening on April 29, 1972. Most of the old rides were located in the Coney Mall section of the park that was designed as a tribute, right down to the midway and the transplanted ginkgo trees.

Coney Island wasn't done yet. The Sunlite Pool remained open. Taft still owned the property, and in 1974, just three years after closing "for good," the resort reopened as more of a park, with tennis courts and paddle boats, as well as the classic Moonlite Gardens, as a way to preserve nostalgia for the place. It was called Old Coney. In 1984, Taft donated fifteen acres of the parkland to the Cincinnati Symphony Orchestra to build Riverbend Music Center, a summer concert venue. Ronald F. Walker bought the much smaller park for $3.8 million in 1991, and carnival-style rides like bumper cars and the Tilt-a-Whirl made a comeback, along with a mild, family coaster, the Python. This incarnation of Coney Island is a charming amusement park for young families—and is still a good place for a picnic—but it lacks the thrill rides that attract teenagers. In 2013, Don Oeters added a miniature Coney Island replica to the massive model train exhibit at EnterTrainment Junction in West Chester, Ohio. The model, which cost over $150,000 to build, depicts Coney circa 1965, complete with operating rides like the Shooting Star and the Lost River, keeping the memories alive.

12

CHESTER PARK

Coney Island had its fair share of rivals. As the Industrial Revolution gave folks more free time for recreation, such as picnicking, swimming and boosting adrenaline on thrill rides, amusement parks popped up all over. Ludlow Lagoon, across the Ohio River in Ludlow, Kentucky, was a major challenger for a couple decades. LeSourdsville Lake in Monroe, Ohio, near Middletown, was more of a blue-collar park. The place for fun within the city of Cincinnati, though, was Chester Park, a popular amusement park on Spring Grove Avenue, near Mitchell Avenue, in Winton Place, a stone's throw from the venerable Spring Grove Cemetery.

There is hardly a sign of the old park now, just a short section of Chester Avenue behind Frisch's Big Boy and some photographs in the lobby of the Greater Cincinnati Water Works offices, which now sit on a portion of the Chester Park site. It is difficult to imagine a full-blown amusement park there, with bathers splashing in the enormous lake and cars ratcheting to the crest of the wooden coasters, all sharing the same industrial neighborhood as the Crosley and Formica plants.

The site of Chester Park had long been used for horse racing. It was known as the Trotting Park when it was set up as Camp Harrison in April 1861 by Colonel William Haines Lytle for training Union troops during the Civil War. Horse racing continued after the war, and in 1875, Captain George N. Stone, along with John Sullivan and John and Charles Kilgour, organized the Chester Park Driving Association for trotting races, more commonly known as harness racing. The name Chester came from Lady Chester,

Stone's favorite horse, whose name derived from Sir Walter Scott's epic poem, *Marmion*: "Charge, Chester, charge!" Stone had fought at Vicksburg and Fredericksburg during the war and later was president of what would be the Cincinnati Bell Telephone Company. Shortly after organizing the driving association, Stone purchased a two-year-old mare that he named Maud S after his daughter, Maud Stone, to run at Chester Park. The horse caught the attention of William Henry Vanderbilt, who purchased her for $21,000. The peerless Maud S went on to set records as the Queen of the Turf. In another brush with fate for Stone, his second wife, Martha, survived the sinking of the RMS *Titanic* aboard the lifeboat with the "unsinkable" Molly Brown.

The first races at the Chester Driving Park were held on October 5, 1875. The first Ohio Derby, won by Bombay, was run on the half-mile oval track. The park was used for other events besides racing and, in 1885, was the site of a boxing contest between champion John L. Sullivan and Dominick McCaffrey. Sullivan did not knock McCaffrey out, as was expected, and backers of both men became so rowdy that the referee wavered and reportedly took the train back to the city before telegraphing the decision in favor of Sullivan. A decade later, Chester Park's fame had faded as mile-long tracks became more prominent in racing, and the park was sold in August 1895. The *Enquirer* painted a portrait of the park's demise with the deck headline: "Its Glories Live Only in Memory. Chester Park a Wreck of Its Early Greatness. Once the Most Famous Course in the Country. Stables and Grand Stand Now Tottering Ruins."[58]

The end of the racetrack was the beginning of something else, a pleasure resort. The Cincinnati Street Railway Company bought the track with the idea that a summer amusement park would be a sufficient draw to entice people to ride its new electric streetcars. Chester Park reopened on May 9, 1896, with a bicycle race, as cycling was all the rage. Built beside the track was a striking Colonial-style clubhouse designed by Alfred O. Elzner, the architect for the Ingalls Building at Fourth and Vine Streets, the first concrete skyscraper. The clubhouse was surrounded by verandas two stories tall and supported by forty columns. Chester Park, like Coney Island, was a summer resort. The season lasted usually from early May to Labor Day.

In 1901, the Cincinnati Street Railway Company leased all its property, including Chester Park, to the Cincinnati Traction Company. The owners gave control of the park to Colonel Isaac M. Martin and his brother J.M. Martin, who were already running things. Colonel Martin had a knack for knowing what crowds wanted and brought in vaudeville acts of all sorts,

ENTERTAINMENT

Chester Park, smack-dab in the middle of an industrial neighborhood, was easy to access by bus, train or streetcar. *Courtesy of the* Cincinnati Enquirer *archives/U.S. Army Air Service.*

from singers and daredevils to a tightrope-walking elephant, but for the theatrical Martin, the emphasis was always on the summer opera.

For the 1902 season, the bicycle track was excavated and turned into a lake. The water came directly from the city's supply, circulated by immense pumps so that the water was always fresh. This, of course, was an enormous cost. The lake was the centerpiece of the park, illuminated with electric lights and an electric fountain. While swimmers frolicked at the sandy bathing beach, boaters rowed around a tiny island where a figurine called the Statue of Liberty stood atop a pedestal and folks strolled along the boardwalk in their finest attire. Chester Park was considered more accessible than Coney Island, which could be reached practically only by boat. There were designated stops for Chester Park along the railroad and several streetcar lines. The Chester Park station for the B&O Railroad was later relocated as an exhibit at Heritage Village Museum in Sharon Woods Park.

The summer opera was phased out in favor of carnival fare like the wriggling staircase and the merry-go-round. The Figure Eight roller coaster replaced the vaudeville house. The Tower Railway was an early roller coaster in which a motor pulled the passenger cars up the hill and then gravity took over down the bumps and turns. The Miniature Railway chugged along a track around the lake. Swimmers at the bathing beach could ride a toboggan down a ramp and skid across the water. The Slide the Slides was a windmill with a slide coiled around the tower. Funhouses like Wun Lung's Laundry

The Tickler ride was destroyed in a fire that consumed four acres of Chester Park in 1911. *Courtesy of the Library of Congress/Detroit Publishing Company.*

and Hilarity Hall were for laughs. Hilarity Hall was one of the most popular attractions because one ticket gave patrons access to games and concession booths, as well as rolling barrels, slides, rocking bridges and unexpected gusts of air from holes in the floor that startled young women.[59] The Tickler, inspired by a ride at Luna Park on New York's Coney Island, put passengers in a car that caromed off rails in a zigzag down a slope, like in a giant pinball game.

Chester Park was nearly destroyed in 1911. On August 14, about 6:00 p.m., a fire started in Storeroom No. 3, a shed underneath the Tickler, near the clubhouse. Before an alarm could be raised, flames swept across the western shore of the lake and consumed four acres of the park, along with the Tickler, Outburst, Figure Eight, Japanese village and Dark Tunnel Coaster attractions; the lunchroom; the Penny Arcade; and the vaudeville theater. The fire then jumped to the M.B. Farrin Lumber Company to the west, destroying everything but the sawmill. The lumber warehouse, also lost, had previously been a stable and the last remnant of the original Chester Park. Underneath the vaudeville stage, Frank Spellman and his wife had to pull their fourteen trained bears, terror stricken by the smoke, out to the bathing beach dressing rooms. One bear broke loose and ran back to the burning

building, causing panicked spectators to flee. All the bears were rescued. The clubhouse, the miniature train and the Derby Racer were relatively undamaged, and the northern part of the park was untouched. There were a few injuries and no deaths.[60] The Farrin Company loss, including three million feet of lumber, was about $150,000, but the damage to the resort was calculated at just $50,000, all covered by insurance. Remarkably, Chester Park did not close for even a day that season. The vaudeville shows were moved to the opera house, and the rides remained open as patrons gawked at the smoking ruins. The park was rebuilt, and "New Chester" debuted for the 1912 season, with new rides, including the roller coasters Blue Streak and Thriller, as well as Hilarity Hall. "Those used to be fun days," recalled William Wilkerson, who worked as a machinist at Chester Park during the 1910s. "You could get to the park for a nickel on a streetcar, and it didn't cost anything to get in the park."[61]

Fending off competition from Coney Island and the many amusements at the nearby Cincinnati Zoo, Chester Park remained very popular. It

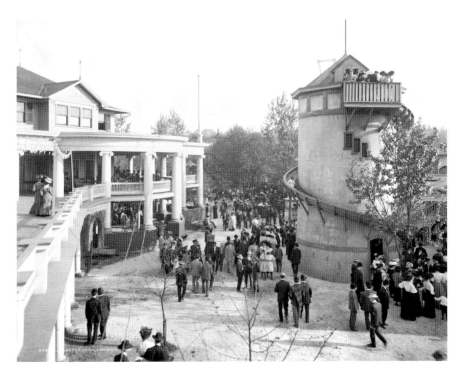

Turn-of-the-century visitors to Chester Park enjoy the clubhouse and Slide the Slides. *Courtesy of the Library of Congress/Detroit Publishing Company.*

offered many special days, such as German Day or Old Newsboys Day. Jack Dempsey, two days after winning the heavyweight title in July 1919, had an engagement at Chester Park. Another fire, on July 19, 1923, destroyed the dance hall and bathing lockers, plus the Cincinnati Car Company factory, totaling $150,000 in damages. In 1926, the park was leased to Charles Bohler, and Colonel Martin announced that black patrons would at long last be admitted. After Martin died, Bohler remade the park, dividing the lake in half and adding a Kiddie Playground and a new roller coaster, the Cyclone. There were also parking spaces for three thousand cars. G.R. Lewis, a well-known park consultant, became chief. For 1929, as part of the makeover, a new name was chosen—Rainbow Park. But the Great Depression, Prohibition and the changing tastes of folks more interested in movies all contributed to a drop in attendance, and though the Chester Park name was restored in 1931, its days were numbered.

Chester Park closed suddenly on August 17, 1932, when the City of Cincinnati shut off the park's water for failure to pay its $1,818 water bill. The lake was always costly to maintain. Chester Park did reopen the next year but had its last day on July 17, 1935. Razing of the buildings and rides started the next day. The swimming pool and skating rink remained as the resort was transformed into a recreational-athletic park. Cincinnati Arena, Inc., purchased the nine-acre site in 1945 and ran the Arena Swimming Pool until the city waterworks built their offices there in 1957. The Cincinnati Traction Company kept the name Chester Park on Route 47 for many years. Though there is little evidence left of the park, it has not been forgotten. Memories have a habit of being colored by nostalgia, and Chester Park has taken on an almost legendary status among those who are too young to have even seen it.

Part IV
BUSINESS

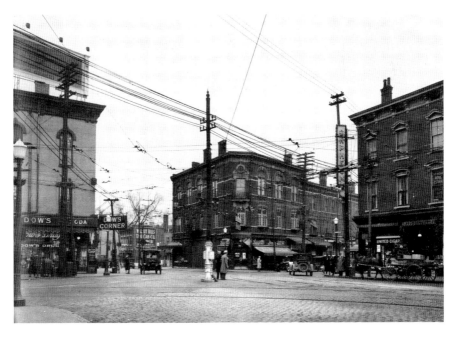

Peebles' Corner was a bustling thoroughfare in the 1920s. *Courtesy of the* Cincinnati Enquirer.

13
TROLLOPE'S BAZAAR

Trollope's Bazaar is remembered for its audacity more than its effectiveness. As a bazaar, or market, it was a failure, lasting only a few months. But the odd design was unforgettable.

Frances "Fanny" Trollope, a cultured Englishwoman, arrived in Cincinnati on February 10, 1828, with hopes of turning her fortunes around. Traveling with one of her sons, two daughters and French artist Auguste Hervieu, Trollope believed that the fastest-growing city in the West would be the perfect place to rescue the family finances. Her plan was to build a mixed-use marketplace where patrons could enjoy coffee and art while purchasing "fancy goods" imported from London and Paris—not exactly a shop for a steamboat town recently carved out of the wilderness. She may have been influenced by William Bullock, an Englishman she met who was planning a European-style city across the river at what would become Ludlow, Kentucky. It would have been a refuge for his fellow countrymen, with circular boulevards, botanical gardens, museums and a library, but no one was willing to come. Back in England, Bullock had built Egyptian Hall, a museum at London's Piccadilly Circus that featured Egyptian structures, columns and figures, all of which may have inspired Trollope. Or perhaps she was ahead of her time, and the bazaar was "the prototype of all such urban experiments in America."[62] Whatever the merits of the idea, the execution was a fiasco.

Trollope purchased a plot of land for $1,655, but since women couldn't own land, the deed had to be signed by her husband, who traveled to

Cincinnati from England in January 1829 just for that purpose. The plot was on the south side of Third Street, between Ludlow and Broadway Streets (411 Third Street by modern addresses), a quarter mile from the fashionable stores and businesses on Fourth Street. She apparently thought her bazaar would be enough of a draw. She hired local architect Seneca Palmer to design a building with myriad architectural influences that ended up being a hodgepodge of Moorish, Egyptian and Gothic elements. The façade, inspired by the Mosque of St. Athanase in Egypt, featured three arched arabesque windows separated by Moorish stone pilasters. A curved divided staircase led to the entrance. Along the roofline, the crests of the Gothic battlements were topped with stone spheres. The south façade was even grander, with a colonnade of Egyptian lotus columns modeled after the temple of Apollonopolis Magna at Edfu in Egypt. Protruding above the roof was a Moorish-styled rotunda with an onion dome. Inside the brick building were four floors. The basement featured a coffeehouse and the start of a spiral staircase that ascended to the rotunda. The main floor was the marketplace, and above that was a ballroom that the artist Hervieu decorated in the style of the Moorish palace Alhambra.[63] Timothy Flint, Trollope's friend and the editor of the *Western Monthly Review*, called the bazaar "a queer, unique, crescented Turkish Babel."[64] It was certainly unlike anything else in Cincinnati. Twentieth-century critic Carl Abbott wrote, "In a city of brick boxes with neoclassical trim…it stood out like a belly dancer in a procession of Greek maidens."[65]

Trollope's Bazaar opened for business in October 1829. While people came to witness the "bizarre bazaar," few wanted to buy anything—not that there was anything worth purchasing. Instead of sending money for the venture, Trollope's husband in England sent her $4,000 worth of unsellable trinkets. Entertainment, such as musicians, recitations, dramatic scenes and the exhibition of Hervieu's masterpiece painting *The Landing of Lafayette at Cincinnati*, failed to bring an audience either. Locals took to calling it Trollope's Folly. In March 1830, after just five months, creditors seized the bazaar goods, and Trollope was evicted. She quickly left town.

When Trollope returned to England, she had her own revenge by writing the travel book *Domestic Manners of the Americans*, published in 1832, which contained a scathing account of Cincinnati. "I never saw any people who appeared to live so much without amusement as the Cincinnatians,"[66] she wrote and complained of their uncouth manners, particularly the spitting. Some of the criticism was founded, as Cincinnati was known at the time as Porkopolis for its prevalent meatpacking industry, and it was common

The eccentric design of Trollope's Bazaar, based on Egyptian and Moorish architecture, continues to fascinate. *From the Collection of the Public Library of Cincinnati and Hamilton County.*

for the hogs to be driven through town on the way to the slaughterhouses. Trollope wrote:

> [I]*f I determined upon a walk up Main-street, the chances were five hundred to one against my reaching the shady side without brushing by a snout fresh*

dripping from the kennel; when we had screwed our courage to the enterprise of mounting a certain noble-looking sugar-loaf hill, that promised pure air and a fine view, we found the brook we had to cross, at its foot, red with the stream from a pig slaughter-house; while our noses, instead of meeting "the thyme that loves the green hill's breast," were greeted by odours that I will not describe, and which I heartily hope my readers cannot imagine; our feet, that on leaving the city had expected to press the flowery sod, literally got entangled in pigs' tails and jawbones: and thus the prettiest walk in the neighbourhood was interdicted for ever.[67]

She didn't mention the bazaar in her book.

Over the years, the building was used for a variety of purposes. Nicholas Longworth was one of the creditors who acquired the bazaar. In 1839, it briefly became the home of the Ohio Mechanics' Institute and then Dr. Alva Curtis's Physio Medical Institute. Later, it was a dance school, a female medical college and "the home of…dreamers and reformers."[68] During the Civil War, it housed convalescing Union soldiers. Before it was torn down in February 1881, the building was inhabited by thieves and prostitutes.[69] The site today is under the Fort Washington Way overpass.

Although not a success for Frances Trollope, her ostentatious bazaar did succeed in garnering attention and continues to be a source of fascination.

14
PEEBLES' CORNER

The name Peebles' Corner has an interesting story of its own. Sometimes mistakenly called People's Corner, perhaps because it was a thoroughfare going as far back as the 1840s, the intersection of Gilbert Avenue and East McMillan Street in Walnut Hills is named for the Joseph R. Peebles' Sons Company grocers that once anchored the northeast corner. The story goes that the grocer would bribe streetcar conductors with cigars or a jug of rum to announce the stop as "Peebles' corner!" instead of the street names. The name stuck and continues to be applied to that section of Walnut Hills, even though Peebles has been gone since the 1930s.

The store began in 1840 as W.S. Peebles' Grocery, a small shop on the northeast corner of Fifth and Race Streets run by William Sharp Peebles, with his brother, Joseph Rusk Peebles, who eventually took over the grocery. After Joseph died in 1866, his son Joseph Straub Peebles continued the family business as Joseph R. Peebles' Sons Company. The store advertised as "Dealers of Staple and Fancy Groceries, and Importers of Wine, Cigars, etc." and dealt with imported goods from Europe in addition to everyday groceries, sometimes receiving orders from customers as far as five hundred miles away. Peebles expanded from its single store, with locations in the Pike's Opera House building on West Fourth Street, later moved to Government Square, and other downtown sites.

On October 1, 1883, Peebles branched outside downtown to Walnut Hills on the northeast corner of Gilbert Avenue and McMillan Street,

what was then known as Kay's Corner, named after another grocer, W.L. Kay & Company. It was here that Joseph S. Peebles reportedly bribed the conductors to shout "Peebles' corner!" The marketing worked. An *Enquirer* want ad two months after the Walnut Hills store opened already referred to the spot as Peebles' Corner.[70] A poster near the store declared: "All roads lead to Rome. All streetcar lines lead to Peebles!" Six streetcar lines ran through Gilbert and McMillan to accommodate the people living in the fashionable eastern suburbs of Hyde Park and Oakley, making Peebles' Corner the busiest district outside downtown.

The Orpheum Theatre on the south side of McMillan, between Gilbert and Kemper Lane, was another landmark near Peebles' Corner. Built by Colonel Isaac M. Martin, operator of Chester Park, the Orpheum opened on December 19, 1909, as a vaudeville theater that also showed motion pictures on its "orpheumscope." The Beaux-Arts theater designed by Chris and Edward Weber included a ballroom, a café and a roof garden that was used as a skating rink in the winter. A second auditorium was added on the sixth floor, and each stage had its own Mighty Wurlitzer theater organ. The organist could play on the first floor, and the slave unit on the sixth floor would repeat the music. In the early 1930s, a young Tyrone Power worked there as an usher.

Dow's Drug Store was a longtime fixture on the northwest corner of the intersection. Cora Dow, the owner, was a graduate of the Cincinnati College of Pharmacy and took over her father's drugstore on Fifth Street when he died. She expanded the drugstore to eleven locations in the area, making it the second-largest chain of drugstores in the nation. Dow was a well-respected business leader notable for hiring female pharmacists and sales clerks and paying them equal to men in the same positions. The Dow stores sold some items at a discount below retail cost, a practice challenged by the manufacturers, but Dow prevailed in court. She sold the Dow Drug Company to an investment group from Cincinnati and Cleveland just weeks before her death in October 1915.

The need for better transportation through the Peebles' Corner district received much civic attention in 1906 with the widening of Gilbert Avenue and the building of the Gilbert Viaduct to better connect downtown to the popular intersection. The Peebles grocery relocated down the street to 2445 Gilbert Avenue about 1920, and Liggett's Drug Store moved into the corner building. The Great Depression hit Peebles hard as fancy groceries, such as caviar and pâté de foie gras, became luxuries that most folks could not afford, and Peebles went out of business in 1935.

The crisscross of streetcar wires demonstrates the heavy traffic through Peebles' Corner, anchored by the Paramount Theater building, in 1940. *Courtesy of the* Cincinnati Enquirer.

The impressive Art Moderne–style Paramount building rose up on the grocery's former Peebles' Corner site on September 4, 1931. The section of the building farther down McMillan Street housed the RKO Paramount Theater, a second-run movie house, while the rounded tower on the corner held McDevitt's men's clothing store. Architect Edward J. Schulte designed the Paramount Theater for Helene Wurlitzer, wife of Howard Wurlitzer of the famous pipe organ company, but RKO had a near monopoly on film distribution in the city and took over operations. Though the theater was two hundred feet from the intersection, a huge spire advertising Paramount was affixed atop the tower on the corner to attract attention to the theater from all directions.

Columbia Parkway, constructed in 1938, provided an alternate route, allowing commuters to bypass Walnut Hills. Business activity in the neighborhood dwindled. The Orpheum was demolished for a variety store in 1953. The Paramount Theater spire was taken down and used for scrap for the war effort during World War II. The Paramount closed in 1961,

and the theater section was razed, though the retail complex remains on the corner as an empty relic. The addition of I-71 in the 1970s and converting McMillan Street and William Howard Taft Road into one-way streets limited access to Peebles' Corner. Vacant storefronts have become a common sight up and down both Gilbert and McMillan. The Peebles' Corner Historic District was added to the National Register of Historic Places in 1985, though the intersection is a shadow of the old days. All that's left is the name.

15

BURNET HOUSE

Hotels in America were established at a time when railroads and steamboats vastly improved transportation. Travelers who used to stay at inns and taverns could then be treated to grand palaces with rooms for hundreds and novel amenities such as running water. It is necessary to put hotels in this perspective in order to recognize their importance and impact in the development and reputation of a city. In that light, the Burnet House, Gibson House and Grand Hotel did the Queen City proud as top-notch hotels throughout the nineteenth century, and the later Sinton Hotel, Palace Hotel and Netherland Plaza continued the tradition. Though few of these landmark hotels survive today, they were instrumental in developing the identity of the Queen City.

The Burnet House had a remarkable reputation, reflecting well on Cincinnati and garnering praise and attention around the world. When it opened in May 1850, the hotel was the cream of the crop in the West. The *Illustrated London News* praised the Burnet House as "one of the finest hotels in the United States."[71] The hotel register would eventually boast presidents and celebrities from Abraham Lincoln to Oscar Wilde. The beginning of the end of the Civil War can even be traced to a planning session held in the Burnet House. So it is no wonder that John Clubbe, in his book *Cincinnati Observed: Architecture and History*, called the Burnet House "one of the Cincinnati buildings I would most like to have seen."[72]

The hotel was named for Judge Jacob Burnet, a judge and politician in the Northwest Territory and during the early days of Ohio's statehood who had previously lived in a mansion on the grounds at the northwest corner of

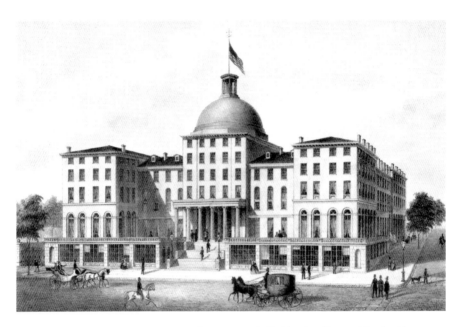

The Burnet House, designed by Isaiah Rogers, was hailed by the *Illustrated London News* as "one of the finest hotels in the United States." *Courtesy of the Library of Congress.*

Third and Vine Streets. Debts forced Judge Burnet to sell about 1825, and he moved to Seventh and Elm Streets. William Shires used the property as a summer garden and theater in 1842. He built a large square-frame theater, and the Burnet Mansion served as a restaurant for customers. Shires' Garden burned down in 1848, and plans were announced to build a grand new hotel to be called the Burnet House on the site.

The Burnet House was constructed by a joint-stock company at a cost of $300,000 and leased to A.B. Coleman as proprietor. The design was by architect Isaiah Rogers, sometimes called the father of the modern hotel. Rogers achieved fame as the designer of Boston's Tremont House (1829), known as the first modern luxury hotel, and New York's Astor House (1836). Rogers relocated to Cincinnati to build the Burnet House and made the Queen City his home. Luxury hotels were relatively rare when the Burnet House opened with a gala event on May 3, 1850.

The hotel formed an *H* shape with five-story wings on each end. A terrace stretched along the second floor, interrupted by a center section set back farther from the street. A grand tiered staircase led to Ionic columns at the entrance. A large dome forty-two feet in diameter capped the six-story center, giving the hotel somewhat the appearance of a capitol building. Atop the dome was a

cupola that afforded a splendid view of the city. The architectural style was Italian Renaissance with Classic Greek touches, a style at the time called Italian Bracketed. The interior courtyard was spanned by an iron bridge that used a braided iron truss invented by Rogers. The basement housed a barbershop and other stores, the terrace level featured parlors and Greek columns ornamented throughout.[73] The hotel had 340 rooms, a tremendous number for a period when inns usually accommodated only a few guests at a time. Charles Cist, an early Cincinnati historian, described the Burnet House shortly after it opened as "undoubtedly the most spacious, and probably the best, hotel, in its interior and domestic arrangements, of any in the world."[74] In 1882, an *Enquirer* reporter toured the famous hotel and provided a rich description:

> *All the rooms visited…were found to be richly papered with the newest styles and designs in wallpaperings—some in blue and gold, others in delicate dove shades, still others in rich maroons, and some in Japanese and Chinese figures, all odd and unique in the extreme, and in exquisite taste.*
>
> *The ceilings were as white as snow, and the carpets—velvet and Brussels—rich in odd designs and beautiful colors. In all the rooms the furniture is of massive mahogany, walnut and rosewood, the designs being more of the style of years ago instead of the light and modern make. The wardrobes are spacious and the beds roomy. The bedclothing for the entire house is of the purest and best of linen. The mantels are all marble, white and colored, and every room is provided with large pier French plate mirrors. Every mattress in the house has been made over new this summer, the pillows and covers are all new, and the bed-spreads, dazzlingly white and clean, are of the finest Marseilles. Some of the rooms are furnished in brown rep, others in green plush, some in crimson velvet, and still others in Japanese figured cloth. The chandeliers, in gold and bronze, with drop-lights, are provided in nearly all the rooms. Nothing so much adds to the refined appearance of a room as lace curtains, and with these, delicate in fiber and beautifully designed, the rooms in the Burnet are abundantly provided.[75]*

Lincoln twice stayed at the Burnet House. On the first occasion, Lincoln was invited to speak to the citizens of Cincinnati on behalf of the Republican Party on September 17, 1859. Reactions to his speech, given from the balcony of a shop on Fifth Street, fell along party lines. The next year, Lincoln's election as president was incredibly divisive amid the rising crises that would erupt as the Civil War. On the way from Springfield, Illinois, to his inauguration in Washington, D.C., Lincoln spent the night of his birthday, February 12,

1861, at the Burnet House. From the hotel balcony, Lincoln delivered a brief speech that did little to tip the president-elect's hand as to how he would handle the growing national crisis, and again reactions were strictly partisan. The favorable *Cincinnati Daily Gazette* described the parade that carried Lincoln from the train depot to the Burnet House: "From the canal to the Burnet House, the streets were lined with thousands of people. From every window and housetop, handkerchiefs waved, and from the people in the street the most enthusiastic and deafening cheers rent the air."[76]

Nearly every person of note who visited Cincinnati from the 1850s to 1870s graced the halls of the Burnet House: Presidents Ulysses S. Grant, Rutherford B. Hayes, Andrew Johnson and James Buchanan; notables Henry Clay, Daniel Webster, Salmon P. Chase, Horace Greeley, Stephen Douglas, Edward Stanton, General Philip Sheridan, General Ambrose Burnside and the Prince of Wales (the future king Edward VII); and even Lincoln's assassin, the actor John Wilkes Booth. Swedish opera singer Jenny Lind and her promoter, P.T. Barnum, stayed in a suite of rooms on the second floor that were thereafter identified by a plaque. Actress Sarah Bernhardt declared the Lind suite the most delightful rooms she had found in America.

The most noteworthy event at the Burnet House was the planning session held by two of the Union's most celebrated generals, Ulysses S. Grant and William Tecumseh Sherman, to make plans for how to end the Civil War. Grant and Sherman checked into the Burnet House on March 20, 1864. At the time, the historic meeting garnered merely a single paragraph in the *Enquirer*.[77] There were no speeches or public announcements. No one knew what was going on behind closed doors. The generals set up in Parlor A on the hotel's second floor and placed sentries at the door to keep eavesdroppers out. They spread maps out on the table and, in a cloud of cigar smoke, devised a strategy to crush the Confederacy. A member of Sherman's staff described the scene: "In a parlor of the Burnet House, at Cincinnati, bending over their maps, the two generals, who had so long been inseparable, planned together that colossal structure…and, grasping one another firmly by the hand, separated, one to the east, the other to the west, each to strike at the same instant his half of the ponderous death-blow."[78]

Sherman was to attack General Joseph Johnston's army in the South and capture Atlanta and the railroads, effectively cutting the Confederacy in two. Grant was to pummel General Robert E. Lee in Richmond, Virginia. Their plan was not exactly the famous "March to the Sea," as is sometimes claimed, though it led to it. Sherman then ordered the burning of Atlanta and cut a three-hundred-mile swath to Savannah, destroying the resources the South needed to

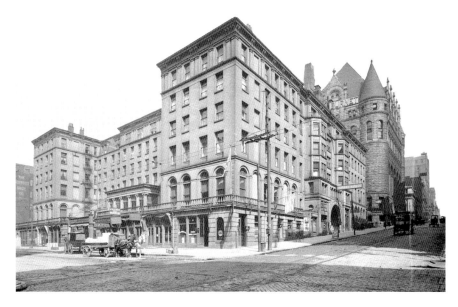

An extensive remodel of the Burnet House removed the dome and created a new entrance on Vine Street. *Courtesy of the Library of Congress/Detroit Publishing Company.*

wage war. For his part, Grant battered Lee's forces until Lee surrendered at Appomattox Court House on April 9, 1865, ending the war. A few months later, Sherman returned to the Burnet House for a reception. He told the crowd of what he called the "historical incident" of the year before. "In this very hotel, and, I believe, in the very room from which I emerged in stepping upon this terrace, we spread out the maps, and consulted and decided upon the routes which the two armies should march. As there and then decided upon, their programme was carried out, and the war concluded," Sherman said.[79] Parlor A became a shrine where the hotel often played host to military gatherings.

In 1885, a major remodel overseen by James W. McLaughlin removed the historic façade and entrance on Third Street, as well as the dome, and created a new entrance on Vine Street, where a grand marble staircase was added. The interior space was enlarged to accommodate more guests to keep pace as one of the grandest hotels in the country. The city was changing, though, and the financial center shifted to Fourth Street. The neighborhood declined. The Burnet House was always considered a fine hotel, but it was in a less desirable locale. By the early twentieth century, it was a relic of a different era.

Behind the hotel on Fourth Street, the Union Central Life Insurance Company had built a skyscraper on the site of the old Chamber of Commerce Building. The company purchased the hotel to build an annex. The Burnet

For the last day of the Burnet House, July 16, 1926, people dressed as the storied hotel's most famous guests, including Abraham Lincoln and Ulysses S. Grant. *Courtesy of the* Cincinnati Enquirer.

House closed on July 16, 1926, with a ceremony commemorating the historic events associated with the hotel. Prominent Cincinnatians appeared dressed as famous guests Lincoln, Grant, Sherman and Lind. Union Central purchased the contents of the room where Lincoln stayed to preserve them and later donated a mirror from the Burnet House to Music Hall, where it hangs in the north hall foyer. Demolition started right away, and the annex was constructed on the site. Careful observers might notice the familiar H-shape of the Union Central Building Annex, now known as the PNC Annex. In 2012, a historic marker was added to commemorate the site of the world-famous hotel.

GIBSON HOUSE

Peter Gibson opened the Gibson House a year before the Burnet House, but he chose to build it on Walnut Street between Fourth and Fifth, what then was the fringe of the city. The site had once been an Indian mound and a cornfield.

Gibson worked in plumbing and invested his money in starting a hotel. The original Gibson House was a five-story block building that lacked the grandeur of the Burnet House. It opened on February 15, 1849, but struggled and closed later that year because it was "so far out in the country and away from the river."[80] It reopened the next year. The hotel proudly advertised a central stairway so as not to disturb guests, but with a fireplace in every room, no fire escapes and only one exit, it was fortunate the hotel didn't suffer a fire. As businesses moved north from the river during the Civil War, the Gibson House was no longer on the outskirts—it was in the new center of town.

The Cincinnati Red Stockings used the hotel as a base of operations in 1869, the year they became the first professional baseball team. In 1873, the building was redone as a grander hotel with three hundred rooms. Plans were already underway to replace the Gibson House with a larger hotel when it was destroyed in a fire on December 10, 1912, though no lives were lost.

Construction of the new hotel started immediately. Architect G.W. Drach created a twelve-story hotel made of brown brick with terra-cotta trim. The new Gibson, now called Hotel Gibson, opened on January 24, 1914. It was

The Florentine Room in the Sheraton-Gibson Hotel was an elegant two-story dining hall for black-tie affairs. *Courtesy of the* Cincinnati Enquirer.

enlarged significantly in 1923 to reach Fifth Street, covering more than half the block. The expanded Gibson was fourteen stories with a thousand rooms, making it one of the largest hotels in the Midwest. The Florentine Room, a two-story dining room, was an elegant affair with marble columns where guests could be serenaded by Glenn Miller's orchestra or a young Doris Day. The Gibson Room was a rooftop garden enclosed in glass. The Sheraton chain purchased the Gibson and Sinton Hotels in 1950, and from then on, it was known as the Sheraton-Gibson Hotel. The Florentine Room was later redone as Kon Tiki, a Polynesian-style restaurant. Over the years, the Gibson hosted a banquet for Charles Lindbergh and a speech by John F. Kennedy, as well as Presidents Rutherford B. Hayes and Franklin D. Roosevelt and the National Governors Conference in 1968 attended by Ronald Reagan.

Despite a renovation in 1971, the Gibson's fate was sealed when developers planned to build a skyscraper on the block the hotel shared with the Albee Theater. The Sheraton-Gibson closed on July 15, 1974. The massive hotel was demolished along with most of the city block, including the Albee, for the First National Bank Tower (now U.S. Bank Tower) and the Westin Hotel.

GRAND HOTEL

The Grand Hotel opened on September 14, 1874, on the western edge of Fourth Street, which had become the city's main thoroughfare. Built for nearly $1 million, a huge sum for the day, the Grand lived up to its name as "a modern hotel in every sense of the word."[81] The handsome six-story hotel on the southwest corner of Fourth Street and Central Avenue was designed by Samuel Hannaford in the French Second Empire style and adorned with balconies and mansard roof structures. The interior and furnishings were opulent, and the lobby was considered the largest around. The hydraulic passenger elevator put the Grand Hotel in the small company of hotels in the country with elevators. In 1892, Hannaford added an immense marble entrance on Third Street to be opposite the new Grand Central Depot under construction. The mansard roof features were later stripped off.

The Grand Hotel served as headquarters for delegates of the 1876 Republican National Convention, held at Exposition Hall (replaced by Music Hall in 1878), in which Rutherford B. Hayes was nominated for president. In the hotel's history, both Hayes and Theodore Roosevelt made

impromptu speeches from the lobby stairway. They were among the eight presidents to stay at the Grand Hotel; others included William McKinley, Warren G. Harding, Grover Cleveland and Chester A. Arthur. Whenever Ulysses S. Grant was in town, he played billiards at the hotel. Other celebrated guests were William Jennings Bryan, General Sherman, Admiral George Dewey and "Buffalo Bill" Cody.

As the city trended toward the east, the Grand Hotel was left behind. Then, when the railroads moved to Union Terminal and the Grand Central Depot closed, it was no longer profitable for the hotel to operate, and it closed on June 1, 1933. The site is now a parking lot beneath an I-71 overpass.

SINTON HOTEL

The Roth family broke into the hotel business with the St. Nicholas Hotel. The first St. Nicholas was a restaurant and saloon opened in 1862 by Bavarian immigrant Balthasar Roth, known as John Roth. It was located on the first floor of the Catholic Institute, later to become the Grand Opera House. After two years, Roth moved the restaurant to a twin-residence building at Fourth and Race Streets, where he could also open a hotel. His son, Edward N. Roth, succeeded him in 1870, and under his management, the three-story St. Nicholas Hotel had a reputation as one of the finest in the West. In January 1903, the hotel was the site of a historic meeting between the National League and American League baseball owners, presided over by Reds president August "Garry" Herrmann. The meeting put an end to the "baseball war" in which the leagues were fighting over player raids and intense rivalries and also established a level playing field between the leagues that set up the first World Series that fall.

In 1905, plans were made to build a new hotel on the lot where Pike's Opera House had burned two years before, with Roth in place as manager. The new hotel at Fourth and Vine Streets was named the Sinton Hotel; Anna Sinton Taft, the daughter of David Sinton, was the most prominent backer. The design by architect F.M. Andrews featured an exquisite main dining hall in Louis XVI style with a swelling dome above and two promenades done in marble. The fancy Chatterbox Club, a roof garden dance hall, required men to wear tuxedos. From its opening on February 25, 1907, the Sinton Hotel was comparable only to the Waldorf-Astoria in New York in terms of elegant hotels.

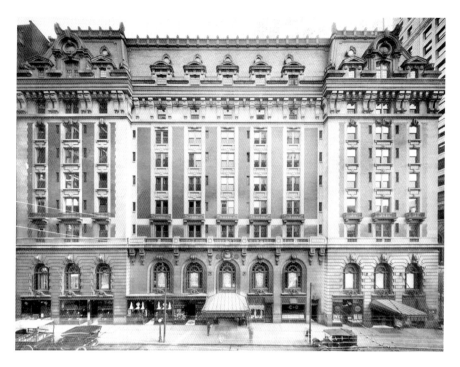

The Sinton Hotel was renowned for its elegance and style. *Courtesy of the* Cincinnati Enquirer *archives.*

The Sinton Hotel was meant in part to be a replacement for the aging St. Nicholas, and the sudden death of Edward Roth in 1910 spelled the end of the older hotel. It closed in 1911. The Sinton Hotel then acquired the rights to the name and was known as the Sinton–St. Nicholas for a time. When the Netherland Plaza Hotel opened in 1931 as part of the Carew Tower complex, it was to be named St. Nicholas Plaza, but the Sinton owned the rights. Since the hotel's silverware had already been monogrammed "St. N.P.," the owners changed the name to Starrett's Netherland Plaza after the developer, though "Starrett's" was quickly dropped.

Among the notable guests to the Sinton Hotel (sometimes called Hotel Sinton) were Thomas Edison; Charles Lindbergh; Sir Arthur Conan Doyle; William Jennings Bryan; Will Rogers; and Presidents Calvin Coolidge, Warren G. Harding, Woodrow Wilson and William Howard Taft. After the Sheraton hotel chain purchased the hotel, rumors began regarding the fate of the Sinton. The axe finally fell, and the Sinton Hotel closed on August 29, 1964. It was torn down to build Provident Tower, now National City Tower.

ORIGINAL FOUNTAIN SQUARE

Fountain Square may be the heart of Cincinnati, but it was hardly the city center when it was unveiled in 1871. Back then, the financial district ran down Third Street, and most activity centered on the river. The space between Vine and Walnut Streets was previously occupied by the Fifth Street Market, a butchers' market house that city leaders found filthy and foul and of which they were all too happy to be rid.

In the nineteenth century, before supermarkets and refrigerators, people living in dense urban areas shopped for goods at public markets on an almost daily basis. Street vendors hawked their finest meat, eggs and produce. Several public markets served Cincinnati at the start of the Civil War. The Lower Market was built in 1804 on Lower Market Street (also known as Pearl), below Third Street between Sycamore and Broadway, and lasted until 1898. The Court Street Market replaced Canal Market between Vine and Main Streets in 1864 but was closed in 1914 as unsanitary. The Sixth Street Market extended from Elm Street to Western Row (Central Avenue) from 1826 until it was torn down in 1960. Findlay Market, started in 1852 on Elder Street in Over-the-Rhine, is the only market left and remains a popular local attraction.

In 1827, the city enlarged a space on Fifth Street for a market, creating a little jog for the road to go around it. The market, with fifty-four butcher stalls, was the most accessible one for the poorer citizens, but many folks found it an unsavory place and self-respecting ladies would never go there on their own. So, when Henry Probasco suggested donating a fountain to the

The Fifth Street Market was torn down in three hours to make way for the new Tyler Davidson Fountain. *Courtesy of the* Cincinnati Enquirer *archives.*

city, it was seen as an opportunity to replace the disgusting market. There was one problem: the market was situated on several parcels of land, some of which were deeded for "the sole use and purpose of erecting a market-house and for a market space, and for no other use and purpose whatever."[82] The butchers sued to stop the project while others, such as architect James W. McLaughlin, suggested better locations for the fountain that were closer to city activities and didn't have the restrictions of the Fifth Street land. The Ohio Supreme Court ruled that since fountains were common in European marketplaces, erecting a fountain did not violate the condition of the land's use for a market. The decision was announced February 1, 1870, and for the next city council meeting, three days later, the city had men with axes and crowbars at the ready for the vote on the market's fate. At 3:00 p.m., the council voted twenty-five to eight to raze the market, and three hours later, it was down.

The fountain that Probasco gifted to the people of Cincinnati is called the Tyler Davidson Fountain, named for Probasco's business partner and brother-in-law. Probasco began as a clerk for Davidson at age fifteen and by 1840 had become his partner. He convinced Davidson to expand his hardware business and build a store downtown. The company became the

largest hardware line in the city, making both men wealthy. Probasco built a mansion in Clifton, where he would later serve as mayor. The splendid Norman Revival estate, called Oakwood, was filled with his extensive collection of books, fine art, plants and trees. Probasco had the idea to donate a fountain as a gesture to thank the city for his and his brother-in-law's success, but the Civil War interfered. Then Davidson died suddenly in December 1865, and the plan evolved to also make the fountain a tribute to Probasco's partner.

Probasco traveled to Europe in search of a fountain design that would be attractive, useful and without the mythological and nautical carvings that were common at the time. He found his design in Munich, Bavaria, at the Royal Bavarian Foundries of Ferdinand von Miller. A drawing made in 1840 by August von Krehling, an artist and sculptor from Nuremberg, had been unrealized for twenty-six years until Probasco selected it for his fountain with some modification. In February 1867, Probasco wrote to the Cincinnati City Council with his proposal to donate a fountain at his expense—eventually costing about $110,000—with the provision that the city would maintain it thereafter. The city council agreed, and after the controversy over the Fifth Street Market, the fountain was shipped from Munich.

The bronze fountain, the most iconic of all of Cincinnati's landmarks, consists of a nine-foot female figure known as the Genius of Water standing atop a pedestal, her arms spread, showering water out of her hands. The fountain represents "the blessings and benefits of water,"[83] illustrated by the figures below her—a farmer hoping for rain, a man seeking rainwater to squelch a fire, a daughter giving her infirm father a cup of water and a mother taking her son to a bath. The pedestal is adorned in bas-reliefs depicting scenes in which water is used, and four figures of children are underneath. Drinking fountains were added at Probasco's request along the edge of the basin; each has the figure of a boy handling an animal—a dolphin, a snake, a goose and, the most recognized, a turtle, with the boy fondly dubbed "Turtle Joe." The entire fountain is forty-three feet high and made of bronze. The basin and base is made of porphyry rock. For the pedestal, Probasco chose a simple inscription to accompany the Genius of Water: "To the People of Cincinnati"; then their names, "Henry Probasco" and "Tyler Davidson"; and the year, "MDCCCLXXI."

The Tyler Davidson Fountain was dedicated on October 6, 1871, as thousands crowded what the city called Probasco Place, though it was Fountain Square almost from the beginning. The city footed the $75,000 bill for the esplanade, designed by William Tinsley. The elliptical boulevard stretched four

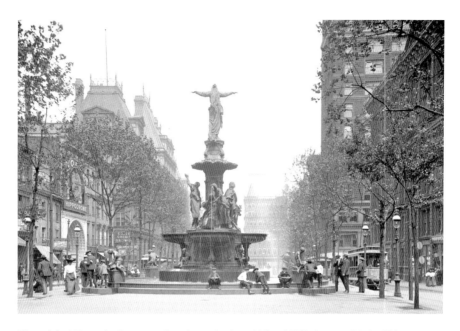

The original Fountain Square esplanade was in the middle of Fifth Street, with the Tyler Davidson Fountain facing east. *Courtesy of the Library of Congress/Detroit Publishing Company.*

hundred feet from Vine Street to Walnut and was sixty feet wide and lined with trees and gaslights. The fountain was draped in white muslin before the unveiling. Ohio governor Rutherford B. Hayes, the former city solicitor and future president, gave an address. The *Commercial* remarked that the fountain "transformed the dingy blocks around it." Within a few years, the formerly objectionable marketplace became the heart of the city.

The fountain, of course, is not lost, but the "square" has been altered considerably. The fountain has also been moved twice to different configurations over the years. The original Fountain Square, as it was for nearly a century, is gone. Then, the fountain faced east, and the esplanade was in the middle of Fifth Street, where traffic was forced to drive around it. People gathered at Fountain Square for events, particularly at Christmastime. The city's first community Christmas tree, a forty-five-foot tree illuminated with two thousand electric lights, was erected at Fountain Square by the Cincinnati Woman's Club in 1913. Celebrations at the end of both world wars and World Series victories brought mobs to the square. It was where the citizens cheered and mourned together. Once a year, the mayor purchased a flower from a wrought-iron flower stand on the square to comply with its use as a marketplace, though the city sued in the 1960s to have the restrictions

eliminated. The flower stand, an unassuming little piece of history, was placed in storage during the 2006 renovation and was not returned.

There were no automobiles when Fountain Square was constructed, but by 1930, traffic congestion was enough of a problem that the city manager proposed moving the fountain to the front of Union Terminal then under construction. People protested, and the idea was abandoned. The city's *Plan for Downtown Cincinnati* in 1964 called for Fountain Square to be more of a public square or plaza on the corner of Fifth and Vine Streets. The city tore down the old Mabley & Carew building and built the plaza on the spot. The fountain was relocated thirty feet east and turned facing west to be visible to oncoming traffic, with the new DuBois Tower (now Fifth Third Center) as its backdrop. After three years of construction, including the addition of an underground parking garage, the new Fountain Square was rededicated on October 17, 1969. The new square was a gathering plaza where people could congregate or bring their lunches.

With the plaza completed, attention was finally paid to the fountain itself. Though the city was obligated by the original agreement with Probasco

The Fountain Square remodel in 1969, on the former site of Mabley & Carew, was a plaza designed for people to congregate. *Courtesy of the* Cincinnati Enquirer.

to maintain the fountain, this proved to be more expensive than originally thought. The first year of upkeep cost $10,000, including paying watchmen around the clock. Costs were cut, and the fountain was not cleaned until 1902—thirty-one years after it was built. After the 1969 renovation of Fountain Square, philanthropist Frederick A. Hauck donated $70,000 for Greek sculptor Eleftherios Karkadoulias to clean and repair the fountain. It was rededicated on the exact day of its centennial, October 6, 1971.

Over time, the bronze fountain took on a green patina called verdigris. The emerald-hued fountain appeared to millions of Americans on television in the opening credits of the show *WKRP in Cincinnati* (1978–82). A study in 1998 determined that the fountain had corroded. The bronze, the structural supports and the plumbing were deteriorating and would require a $1.5 million restoration, or the fountain could crumble. The fountain was originally finished in pewter, but the 1971 restoration used abrasives and pigmented wax that made the bronze incompatible with a new pewter coat. Instead, a dark brown patina, a new color for the fountain, was applied.[84] A temporary glass shelter was erected on Fountain Square while the restoration was completed, eventually costing $2.2 million. The Tyler Davidson Fountain was again dedicated on May 6, 2000.

The second incarnation of Fountain Square quickly became dated, and what once was praised by urban planners as welcoming was then judged as harsh. An awkward stage pavilion was added in the northeast corner of the square in 1985 and distracted from the emphasis on the fountain. The Albee Theater and Sheraton-Gibson Hotel were razed for the Westin Hotel and the First National Bank Center (now the U.S. Bank Tower) as part of a revitalized downtown section called Fountain Square South. An atrium in the Westin was intended to be an indoor space that was an extension of the square like Boston's Faneuil Hall. But no one lingered there, and it was derided as a "vapid interior space."[85] There were more problems. Attempts to make a Fountain Square West across Vine Street fell through. The skywalk system that connected downtown buildings with covered walkways also kept people off the sidewalk and off the square. The parking garage underneath leaked and was structurally compromised. City leaders decided that a revitalized Fountain Square, one that was a destination instead of a "drive-by" square, would jumpstart downtown development.

So, just five years after the fountain was restored, the entire square was renovated once again. The $48.9 million project was managed by the Cincinnati Center City Development Corporation (3CDC). The square closed for nearly a year as a new underground garage was built and the

plaza was regraded to be closer to street level. The Genius of Water figure was temporarily moved to the Cincinnati Art Museum, where people got their first close-up look at their favorite lady. The Tyler Davidson Fountain was moved to the center of the square and shifted to face south. The third incarnation of Fountain Square opened on October 14, 2006. A large LED screen was placed above Macy's on Vine Street and is sometimes used to show community events. In the winter, a skating rink is set up on the square while during the summer, there is a concert or activity nearly every night. These days it seems the heart of the city is always beating.

17

MABLEY & CAREW

Major cities in the early twentieth century were anchored by their own big-building department stores. Chicago had Sears and Marshall Field's, Detroit had Hudson's and New York had Macy's. Cincinnati had Shillito's, Pogue's and Mabley & Carew. Folks did all their shopping downtown, especially during the holidays, when it was a tradition to hop a streetcar for a full day of shopping, lured from store to store by the displays of Christmas pantomimes and the Shillito's elves. Department stores began around the 1870s as independent businesses selling dry goods or clothing at a time when Americans were moving away from a rural lifestyle into city living. The stores expanded to fit the need, competing for ownership of each corner of the market. As people moved to the suburbs, shopping malls were more convenient than downtown stores. Online retail and low-price megastores have since cut into the market. The once mighty retailers have dwindled, consolidated and nearly disappeared, but the names of those stores still resonate with locals, even decades after their signs have been taken down.

The Mabley & Carew Company operated for one hundred years at Fifth and Vine Streets, at different times occupying three of the four corners of the most visible intersection in the city on the edge of Fountain Square. The store dates back to 1877, formed as a partnership between Christopher R. Mabley and Joseph Thomas Carew. According to the company's "diamond jubilee" booklet, the favored story of the origin, though not verified, comes from the *Times-Star*'s obituary of Carew in 1914. The story goes that early in 1877, Mabley, who owned the Mammoth Clothing Establishment in

Detroit, was traveling from there down to Memphis with his young business lieutenant, Carew, when they missed their train connection in Cincinnati. Wandering the city, Mabley spotted a "for rent" sign directly across from the statue at Fountain Square and realized it would be an ideal location for a new store.

Whatever the circumstances of why Cincinnati was chosen, Mabley rented 66 East Fifth Street on the west corner of Lodge Alley between Vine and Walnut Streets and soon added more buildings. On March 31, 1877, Mabley the Clothier opened an eighteen-foot storefront selling gentlemen's and boys' clothing. Mabley remained in Detroit and set Carew in charge of the new Cincinnati store. They became partners as Mabley & Carew until Mabley's death in 1885, when Carew took complete control, though he kept his partner's name on the company.

Architect James W. McLaughlin was hired to tear down the old stores and erect a new six-story building with ten stores covering the block between Lodge Alley and Vine Street. The Mabley & Carew building opened for business on October 23, 1889. McLaughlin's Richardsonian Romanesque design was noted for the fifth-story arches, the distinctive clock protruding from the corner and, on the first floor, enormous French plate glass windows fifteen feet wide and ten feet tall, the largest in the city at the time. Inside, a grand marble staircase led to a raised platform, affording a terrific view of the sales floor. At night, ten thousand electric lights outlined the edges and windows, lighting the entire building like a huge Christmas display.

Mabley & Carew became famous during the holidays for its Christmas pantomimes, starting in 1890 with "Little Red Riding Hood" and a visit from Santa Claus. The pantomimes were presented on a temporary balcony on the second story along Fifth Street, facing audiences on Fountain Square. In 1892, the company commissioned Cincinnati artist Joseph Henry Sharp to paint "Fountain Square Pantomime" depicting the people crowding near the fountain to watch the show. The tradition lasted until 1923. Mabley & Carew was also closely associated with Arbor Day for giving out thousands of trees to schoolchildren to plant, beginning with fifty thousand catalpa trees in 1910. The popularity of the company's annual gift helped it catch on nationwide.

For many years, J.T. Carew complained about the "nasty corner" directly opposite the store at the southwest corner of Fifth and Vine Streets. Carew fulfilled his promise to erect a handsome building there with the construction of an eight-story office building on the corner in 1891. The Carew Building, also designed by McLaughlin in the Richardsonian Romanesque

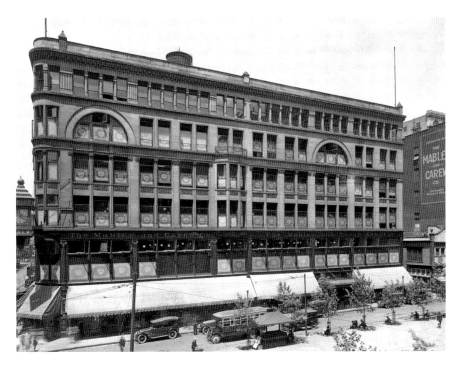

The Mabley & Carew building, designed by Cincinnati architect James W. McLaughlin, had an ideal location next to Fountain Square. The wrought-iron flower stand is visible in the foreground beside the bus. *Courtesy of the* Cincinnati Enquirer.

style, featured a prominent clock tower and was credited with raising the standards of the business district. After Carew died in 1914, the Thomas Emery Corporation purchased Carew's namesake building. Just before the stock market crash in 1929, Emery announced plans to replace it with a skyscraper to be called Carew Tower.

The $33 million project included a forty-eight-story office tower (the forty-ninth floor is the observation deck) and the Netherland Plaza Hotel, as well as five levels of retail space. Carew Tower would be the tallest building in Cincinnati until the completion of the Great American Tower in 2011. Chicago architect Walter W. Ahlschlager designed Carew Tower in the Art Deco style that was spreading like wildfire. The mixed-use skyscraper is said to have influenced Rockefeller Center in New York City. After fifty-three years, the Mabley & Carew Department Store hopped across the street and occupied the first five levels of Carew Tower, reopening for business on October 7, 1930.

While Mabley & Carew blossomed in Carew Tower, the old store was difficult to sell because it was divided into five parcels. So it was rented out. It

fell into disrepair to the point that a building once heralded as a palace came to be called "Old Eyesore." The top three floors were removed in 1957, making for an even more unsightly structure in the heart of the city. It was demolished in 1965 to make way for the redesigned Fountain Square at the spot C.R. Mabley and J.T. Carew had chosen as a perfect location.

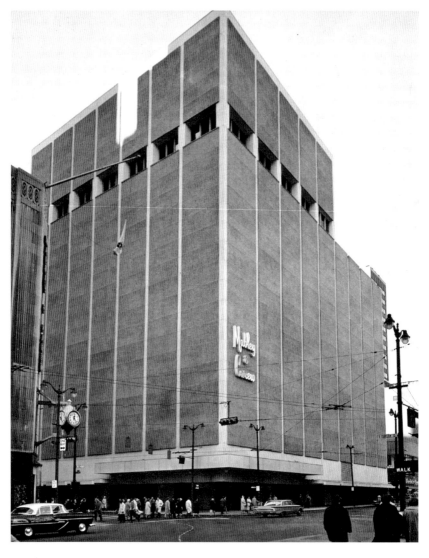

The transformation of the 1923 Rollman's building into the modern Mabley & Carew store in 1962 was expected to enhance the attractiveness of downtown. *Courtesy of the* Cincinnati Enquirer/*Herb Heise.*

BUSINESS

On the northwest corner of Fifth and Vine Streets was the Rollman & Sons Department Store, started by Isaac Rollman in 1867. Rollman's was billed as "Cincinnati's most progressive store," constantly adding more "stores" or departments and expanding its space. Rollman's built a twelve-level store in 1923, then purchased the Havlin Hotel next door and incorporated the building into the store in the 1947 remodel. Allied Stores Corporation purchased Mabley & Carew in 1960, then acquired Rollman's two years later and shut it down. Mabley & Carew was then moved across the street to the Rollman Building after it first had a complete makeover. The building was encased in a modern façade of blue mosaic stone with a single row of windows exposed on the tenth floor. The store looked like a large L-shaped box, but at the time, the *Enquirer* declared, "The beauty of the structure, inside and out, with its precast walls of Wedgewood blue providing a real adornment of picturesque Fountain Square, will go a long way toward enhancing the attractiveness of downtown Cincinnati."[86]

When Mabley & Carew vacated Carew Tower, Pogue's moved in. The H&S Pogue Company department store was founded in 1863 by brothers Henry and Samuel Pogue when they took over their uncle John Crawford's dry goods store on West Fifth Street. They relocated to Fourth Street in 1878 and continued to expand, replacing buildings in stages. The landmark Pogue's store at 20 West Fourth Street, designed by architect Harry Hake, opened in 1916. When Carew Tower was built, Pogue's added an arcade to connect the two buildings. Once Pogue's moved into Mabley & Carew's old space, its expanded store had entrances on both Fourth and Fifth Streets. At Christmastime, it converted the Carew Tower arcade into the Enchanted Forest with talking interactive reindeer, Pogie and Patter, which were holiday favorites.

Mabley & Carew was sold to Dayton-based Elder-Beerman in 1978, and all its stores were converted to the other brand. The name Mabley & Carew was gone. The downtown store closed in 1985, and the city bought the property to build a skyscraper at the planned Fountain Square West. The building was torn down in 1991, but the development was never realized. In 1997, the three-story Fountain Place was built for Lazarus (later Macy's) and Tiffany & Co. The name Pogue's was also phased out starting in 1984 as the stores took the name of their sister company, L.S. Ayres. The Fourth Street store closed in 1988 and was demolished the next year for the Tower Place Mall attached to Carew Tower. In a twist of fate, the names Mabley and Carew were rejoined in 2014 when the now-closed mall was transformed into a parking garage and retail space called Mabley Place.

JAMES W. MCLAUGHLIN

McLaughlin, "the most important Cincinnati-born architect during the second half of the nineteenth century,"[87] was the chief rival of Samuel Hannaford. Between them, they forged the architectural style of the city. Born in 1834, McLaughlin was the son of early Cincinnati merchant William McLaughlin, and the brother of George McLaughlin, a sculptor, and M. Louise McLaughlin, a pioneer advocate of American pottery art. At age fifteen, McLaughlin studied under Cincinnati architect James Keys Wilson, and in 1857, he partnered with John R. Hamilton to design the eclectic Byzantine-styled Masonic Temple with the mansard roof at Third and Walnut Streets, replaced by the current Masonic Temple in 1928.

After serving under General John C. Frémont in California during the Civil War, McLaughlin returned to his hometown as one of the city's most prominent architects. Though heavily influenced by H.H. Richardson at times, he could also be innovative. Many of his greatest works have been lost, including the Main Library (1871), the Bellevue House (1876), the Hamilton County Courthouse (1886), the Mabley & Carew building (1889) and the YMCA building (1891). But enough of his works have survived to demonstrate his legacy.

One of McLaughlin's earliest commissions was for the John Shillito Company, the oldest department store in the city. John Shillito had been a business partner of McLaughlin's father before establishing one of the largest dry goods stores west of the Alleghanies. McLaughlin designed a new store for Shillito in 1857 on the south side of Fourth Street, between Vine and Race Streets, that later was home to McAlpin's for more than a century. McLaughlin designed another Shillito's store at Seventh and Race Streets in 1878. The spacious emporium had six floors of retail space surrounding an enormous atrium highlighted with a forty-five-foot diameter hexagonal skylight and a grand wrought-iron staircase. It was one of McLaughlin's most recognizable structures, but it underwent an Art Deco makeover by George Marshall Martin in 1937. A shell of granite, limestone and marble was wrapped around the building on three sides, though McLaughlin's original design can still be seen down Shillito Place.

Several of McLaughlin's works can be found in the city: the St. Francis Seraph Church (1859), Vine and Liberty Streets; the Cincinnati Gas Light and Coke Company building (1872), 305 West Fourth Street; original structures at the Cincinnati Zoo (1874–75), including the Reptile House, designed as the Monkey House; and the Cincinnati Art Museum complex (1882–86) and Cincinnati Art Academy (1887).

McLaughlin died in New York in 1923 and is buried in Spring Grove Cemetery.

Part V
LIVING

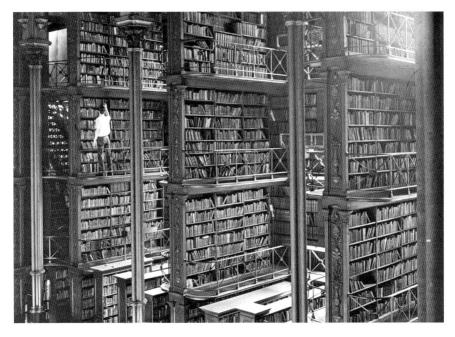

The shelves of the Old Main Library featured cast-iron book alcoves and spiral staircases.
From the Collection of the Public Library of Cincinnati and Hamilton County.

18

HISTORIC HOMES

It should be remembered that in 1858, George Washington's Virginia home, Mount Vernon, was sitting neglected in a state of disrepair until Ann Pamela Cunningham raised funds to purchase and preserve the mansion. If ever there were a home in America that should be saved, it was Mount Vernon, and it nearly didn't happen. That fact may help explain Cincinnati's inconsistent track record in preserving its own heritage. For every Taft birthplace or Harriet Beecher Stowe House saved, a Gamble house is lost, sometimes despite the herculean efforts to save it.

LYTLE HOMESTEAD

Lytle Park, a quiet refuge on East Fourth Street, is named in honor of Brigadier General William Haines Lytle, the Civil War hero and poet who made his home there. That land was also home to five generations of the pioneering Lytle family dating to before the city's beginning. Lytle's great-grandfather Colonel William Lytle fought in the French and Indian War and, with his son, also named William Lytle, was among the settlers headed down the Ohio River in 1780 who landed at the mouth of the Licking River and fought off an encampment of Indians on the Ohio shore. Though the families didn't stay, this occurred eight years before Losantiville was settled there. The younger William Lytle went on to become a general in the War

of 1812. He founded Lytletown (now Williamsburg) in Clermont County in 1801 and helped start Cincinnati College. He purchased eight acres in the area that is now Lytle Park and built a brick mansion at Symmes (now Third) and Lawrence Streets in 1809. It was one of the first brick homes in the Northwest Territory; all the bricks were brought downriver from Pittsburgh. Later, the house was moved to 366 Lawrence Street. For decades, the Lytle, Longworth and Taft families lived in stately homes around Lytle Square.

William Haines Lytle was born in the house in 1826. His father, Robert Todd Lytle, was a popular lawyer and politician who served one term in the U.S. House of Representatives and had a gift for speech that earned him the nickname "Orator Bob." The Lytles were strong Jacksonian Democrats and hosted President Andrew Jackson at the house in his only visit to the Queen City in 1834. Following in his father's footsteps, William Haines Lytle served two terms in the Ohio House of Representatives and ran unsuccessfully for lieutenant governor. Though Lytle was against abolition, when war broke out in 1861, he was ready to fight to preserve the Union.

Lytle established Camp Harrison at the future site of Chester Park and then was put in charge of the Tenth Ohio Volunteer Infantry, a regiment known as the Bloody Tenth because of its heavy losses. Lytle, the "poet-warrior," is mostly remembered for his poem "Antony and Cleopatra," first published in the *Cincinnati Commercial* in 1858. The famous opening about Marc Antony sacrificing himself for Rome—"I am dying, Egypt, dying!"—portends Lytle's own sacrifice.

At the Battle of Perryville in Kentucky, Lytle was struck in the head with shrapnel and taken prisoner by Confederates. After his release and recovery, he led his troops at the Battle of Chickamauga in Georgia, the second-bloodiest battle of the war. On September 20, 1863, Lytle was shot in the spine but stayed on his horse. Another bullet hit him in the face, and he died on the battlefield. The whole of Cincinnati mourned his passing. Lytle was buried in Spring Grove Cemetery under a tall Italian marble monument near the cemetery entrance. A bas-relief depicts Lytle on horseback leading a charge at Chickamauga.

After Lytle's death, the property stayed in the family. Around 1900, city councilman Mike Mullen of Boss Cox's Republican political machine advocated turning the Lytle land into a public park and playground. Despite protests over losing the nineteenth-century charm of the neighborhood, the city purchased the land for $242,000. Lytle Park was dedicated on July 6, 1907. But Mullen wasn't done. He wanted the Lytle mansion razed because

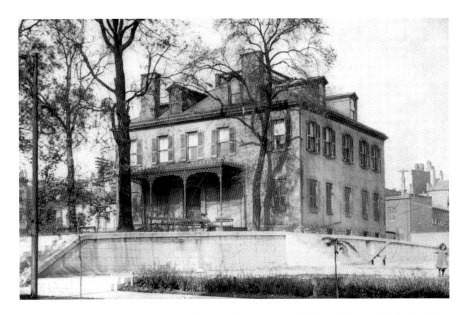

The Lytle mansion was the home of several generations of the celebrated Lytle family, but the home was not preserved. *From the Collection of the Public Library of Cincinnati and Hamilton County.*

he felt it marred the beauty of the park. Philanthropist Mary Emery offered $50,000 to repair and maintain the house, but the city council declined. The historic home was torn down in 1908. It may not have been fancy by modern standards, but its historical value was immeasurable.

THE PINES

The vast estate known as the Pines was the heart of Hyde Park even before there was a Hyde Park. Thomas Wade, a Revolutionary War veteran and early settler of the Columbia settlement, purchased the tract of 160 acres from John Cleves Symmes for $106 in 1795. Wade built a simple farm on land that today is bordered by Observatory Avenue, Paxton Avenue, Wasson Road and St. John Place. He sold the property in 1806 to Reverend William Jones, who then sold it to James Hey in 1818.

Hey, an Englishman, found Cincinnati a fetching place to retire. He reimagined the farmland as a country estate he called Beau Lieu Hill Farm, French meaning "beautiful place." In 1827, Hey built a three-story mansion

fit for a gentleman, with flower gardens, stables and a wine cellar with rare vintages. The house was surrounded with "noble trees and beautiful drives and parks, winding in and out among beautiful gardens hedged with boxwoods. The fields were hedged with Osage orange and English hawthorn."[88] Hey died in 1845 and was buried between two giant oak trees that still stand at 3521 Bayard Avenue. The property was sold to Ruckard Hurd and then to John Kilgour in 1863.

Kilgour and his brother Charles, who combined to own the Cincinnati Street Railway Company and Cincinnati and Suburban Bell Telephone Company, were driving forces behind the development of Hyde Park. Kilgour renamed the estate the Pines after the enormous pine trees that towered over the mansion. He remodeled the house with a mansard roof and verandas and lived there until his death in 1914. His son sold off portions of the estate for development, with the most desirable plots going to Myers Y. Cooper, the one-time Ohio governor. Cooper acquired the last acres in 1939, and resided in the Pines until his death in 1954.

The Cincinnati Board of Education wanted the land for a new junior high school, triggering a property dispute. Most of the community, including the City Planning Commission, called to preserve the picturesque estate; however, the board threatened to use eminent domain, and the Cooper heirs agreed to sell the property. The Pines was torn down on December 20, 1966. Walter Peoples Middle School was built on the spot of the old mansion, and it was replaced with the new Clark Montessori School in 2010.

SHILLITO MANSION

The palatial Mount Auburn home owned by John Shillito had quite a pedigree in Cincinnati history. Though best known as the home of the department store magnate, the house was built about 1857 as the home of Truman B. Handy, the developer whose uncompleted opera house became the public library. James W. McLaughlin designed the Elizabethan Renaissance mansion for Handy in Mount Auburn, which was considered a rural area at the time. Built of blue limestone, it had an impressive entrance flanked by statues of clawing lions. The Victorian-styled roof was paired with an arresting ogee trefoil parapet. In the grand hall was a seven-foot-wide English fireplace with a ceiling-high mantel of black walnut and maple, ornamented in woodcarvings of three life-size female figures representing

Peace (depicted with a dove), Plenty (with a cornucopia) and Harmony (with a lyre). Interior details included frescoed ceilings and black and white marble tiles.[89] Handy, who often shuffled financial deals and fortunes, sold the home to Shillito in 1866.

Shillito passed away in 1879. In 1901, the family sold the homestead to the Cincinnati Conservatory of Music, an eminent music school founded by Clara Baur in 1867. The home was an answer to Baur's prayers regarding a move to the hilltop community. It was used as the administrative building, while several structures were added to expand the campus, all in harmony with the vintage architecture on Oak Street such as the Vernon Manor and the Gibson-Hauck House. The conservatory merged with the College of Music of Cincinnati; then, the new College–Conservatory of Music, or CCM, became a part of the University of Cincinnati. New facilities on the UC campus would be necessary, of course, and Mary Emery Hall and the Corbett Center for the Performing Arts opened in 1967. CCM's Oak Street campus was closed, and the buildings, including the Shillito mansion, were torn down. Cincinnati Public Schools built C.M. Merry Junior High School there in 1968. When the school closed in 1993, the buildings were converted to the CPS central offices and the Mayerson Academy.

Schmidlapp Mansion

Financier Jacob G. Schmidlapp left a tremendous legacy of philanthropy. Primarily a banker, Schmidlapp made his fortune by distilling whiskey before founding the Union Savings Bank and Trust Company, which merged with Fifth Third National Bank. His philanthropic efforts were in the form of memorials to his wife and daughters, who were killed in two tragic accidents. In their memory, Schmidlapp created a scholarship fund for young women and the Schmidlapp Wing to the Cincinnati Art Museum, which now serves as the museum's main entrance. He also started the Cincinnati Model Homes Company to build low-rent model homes for the city's working poor, particularly black families, at the Washington Terrace complex in Walnut Hills.

Schmidlapp made his home at 2235 Grandin Road in East Walnut Hills in a mansion he called Kirchheim. The manor was on forty-nine acres overlooking the Ohio River. Schmidlapp purchased the estate from the late William Hooper in 1895 for $150,000 and added $15,000 of remodeling

to the stone mansion built about ten years earlier. Kirchheim hosted grand receptions and was well admired as one of the handsomest homes in the Queen City. After Schmidlapp's death in 1919, the remainder of his estate was given away, and Kirchheim was handed down to his sons, who apparently didn't need the mansion, as it was torn down.

Remus Mansion

George Remus, the "King of the Bootleggers," made his home in a mansion in Price Hill, an old west-side neighborhood that would never be confused with the affluent Clifton, Hyde Park or Indian Hill. But then Remus would never be confused with the Crosleys, Kilgours or Schmidlapps, either.

The German-born Remus was a criminal defense lawyer in Chicago. When Prohibition started, the savvy Remus looked for loopholes in the Volstead Act and found that it was legal for whiskey to be sold for medicinal purposes. Since he owned pharmacies, he could legally acquire whiskey, and the shipments would "disappear" during transport from the distilleries. Remus moved to Cincinnati in 1920 because it was centrally located to the largest whiskey distilleries. He ran his operation out of Death Valley, a barren spot with a farmhouse and sheds on Lick Run (now Queen City Avenue) at the intersection with Gehrum Lane in Westwood. Bootlegging made him a millionaire nearly overnight.

Remus bought a mansion at 825 Hermosa Avenue owned by Henry Lackman of the Lackman Brewing Company that was secluded on acres of land bounded by West Eighth Street, Greenwich Avenue and Rapid Run Pike. Remus added $100,000 for an additional wing and a Grecian swimming pool lined with Rookwood tile. He threw lavish Jazz Age parties there and gave extravagant gifts, such as diamond earrings and stickpins to each guest on New Year's Eve 1921.

While Remus was in prison for tax evasion and bribing officials, his wife, Imogene, hooked up with FBI agent Franklin Dodge, and together they sold all of the belongings of the Price Hill mansion and tried to get Remus deported. When Remus was released, he found that his fortune was gone, and Imogene filed for divorce. On the morning of October 6, 1927, Imogene and her daughter left the Alms Hotel in Walnut Hills in a taxi, headed to court. Remus, waiting in his touring car, had his driver follow her in a wild chase. The car forced the taxi off the road near the gazebo in Eden

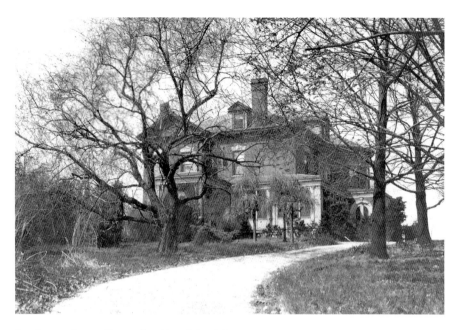

Bootlegger George Remus lived in a Price Hill mansion, but he never returned to it after he killed his wife. *Courtesy of the* Cincinnati Enquirer.

Park, and Imogene fled the cab. Remus ran after her and shot her. Imogene was taken to the hospital, where she died, while Remus walked to the police station and turned himself in.

The "trial of the century" was considered a sure thing since Remus confessed to the murder. The prosecuting attorney was Charles P. Taft II, the son of William Howard Taft. Remus defended himself in court with the audacious plea that he had been driven temporarily insane by his wife's actions. The tricky part was convincing the judge he was now competent enough to act as his own counsel. After deliberating for nineteen minutes, the jury found Remus not guilty. He served three months in a mental institution in Lima, Ohio, and then lived out his days in relative obscurity in Covington, Kentucky.

Remus never returned to his Price Hill mansion after the trial. It was sold in 1934, and the land was divided up. A wrought-iron fence from one of the estate's entrances is said to be the gate at the rear of Elder High School on Panther Court. Apartment houses occupy the corner of West Eighth Street and Hermosa Avenue, and brick homes fill up an extension of Ridgeview Avenue over the former Remus property.

Gamble House

James Norris Gamble was born in 1836, a year before his father, also named James Gamble, joined William Procter to found Procter & Gamble. Young Gamble attended Kenyon College at age fourteen and was educated in science and chemistry in colleges back east. In 1879, Gamble created Ivory soap, "the soap that floats" that was "99 44/100% pure." The soap became P&G's signature brand. As vice-president of P&G, he supervised the construction of the Ivorydale plant in St. Bernard in 1885. Ever the philanthropist, Gamble helped found Christ Hospital in honor of his mother, Elizabeth Gamble, and funded UC's Nippert Stadium to honor his grandson, James Gamble Nippert, who died from blood poisoning after being injured by spikes during a UC football game.

Gamble lived in a thirteen-room Victorian home at 2918 Werk Road in Westwood for fifty-seven years and was a staple of the blue-collar neighborhood, serving as the last mayor of Westwood before it was annexed to Cincinnati in 1896. He named the home Ratonagh after his ancestral town in Northern Ireland. The Gamble family purchased the sixty-acre property about 1830; the earliest section of the house was a farmhouse built in 1840. Gamble inherited the property in 1875, and it dwindled over the years to eleven acres. He died in his home in 1932. His daughter Olivia and grandson Louis Nippert, owner of the Reds during the Big Red Machine years, kept the house as it was when Gamble had lived there. When Nippert died in 1992, ownership passed to his wife, philanthropist Louise Nippert, who handed the house over to the Greenacres Foundation, an Indian Hill–based foundation set up and run by the Nipperts. As of 2008, when the Westwood Historical Society toured the home, it still looked as it had the day James N. Gamble died.

In 2010, Greenacres petitioned to have the Gamble house demolished, claiming it was unable to afford the upkeep. Neighbors and preservationists attempted to save the home, and the city council named it a historic landmark. Meanwhile, Greenacres gutted the home of all its fixtures. *Enquirer* columnist Cliff Radel wrote extensively about the plight of the Gamble house, noting that according to the Greenacres' attorney, the restoration costs ranged from $1.3 to $3 million, and restoring the house was "not economically feasible." Yet Greenacres' tax return that year listed its assets at $227 million,[90] and five years earlier the foundation had donated $3 million to preserve the historic estate of yeast baron Julius Fleischmann in Indian Hill. Offers to buy the home and restore

LIVING

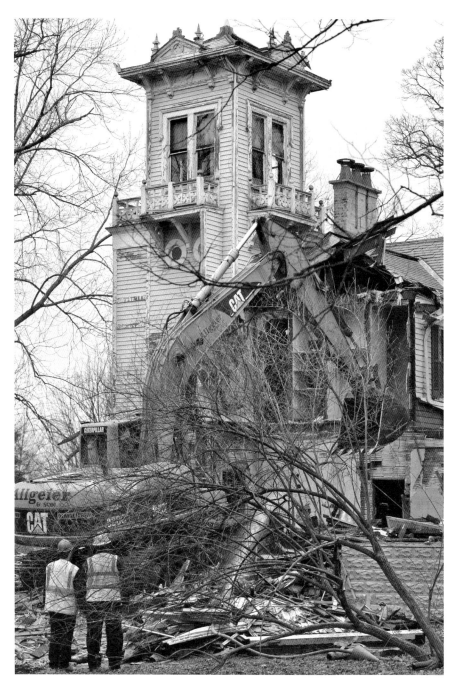

The Westwood home of philanthropist James N. Gamble was torn down despite widespread efforts to save it. *Courtesy of the* Cincinnati Enquirer/*Carrie Cochran.*

it were rejected, and the city council's efforts to halt the demolition fell short. After all legal recourses had been exhausted, the Gamble house was demolished on April 1, 2013.

19
NEIGHBORHOODS

Some of the city's poorer neighborhoods have been wiped away over time with little evidence they were ever there. These slums may not have been desirable, but they were key components in the city's identity. More importantly, for thousands of people, they were home.

Bucktown

The most notorious, crime-ridden section of town in the decades before and after the Civil War was known as Bucktown, the swampy area east of Broadway, between Sixth and Seventh Streets out to Culvert Street. The largely African American neighborhood was further burdened with the influx of former slaves flooding in after the war. The poverty-stricken area became a den of crime. People of the lowest type—prostitutes, thieves, brawlers and drunkards—frequented saloons with levee hands and dockworkers. They lived in squalor in ramshackle shanties or in dens with flat roofs at street level and the dwellings underground. Murders were so commonplace that Broadway and Sixth Streets was known as "Dead Man's Corner."

Lafcadio Hearn, the first of a new breed of tell-it-like-it-is journalists who wrote about the ghastly details of topics not usually covered, had great interest in Bucktown and its denizens. Hearn described what he called "this little Gomorrah" in a piece for the *Cincinnati Commercial* in 1875:

Bucktown…was once not less celebrated as a haunt of crime than the Five Points of the Metropolis. Lying in the great noisome hollow…the congregation of dingy and dilapidated frames, hideous huts, and shapeless dwellings, often rotten with the moisture of a thousand petty inundations, or filthy with the dirt accumulated by vice-begotten laziness, and inhabited only by the poorest poor or the vilest of the vicious, impressed one with the fancy that Bucktown was striving, through conscious shame, to bury itself under the earth.[91]

Policemen on the Bucktown beat worked to clean up the streets "by sending most of its tough men and women to the hospital or workhouse," and by the 1890s, the worst element was gone so that "sometimes several nights would pass without any one being killed."[92] The Bucktown properties were gradually bought up and leveled for warehouses, and by 1910, the notorious district had been wiped off the map.

THE BOTTOMS

When the Cincinnati riverfront was bustling during the steamboat age, a neighborhood sprang up as home to merchants, dockworkers and immigrants. The Bottoms covered from the Ohio River to Sixth Street, east of Walnut Street all the way to the base of Mount Adams. Being close to the river, it was an area of frequent flooding, and some sections accommodated dockworkers and roustabouts with boardinghouses, saloons and bordellos—the most popular of the latter were run by the kind-hearted madam Maggie Sperlock. The action was on Front Street, about where Mehring Way is located today, where the "hotels and taverns played host to royalty and commoner, adventurer and banker, artists and soldier, roustabout and farmer, laborer and gambler."[93] The section between Broadway and Main Streets, known as the Levee, was frequented by black residents; Rat Row, between Walnut and Main Streets, was more of a mix of whites and blacks; and Sausage Row, between Broadway and Ludlow Streets, had higher-quality houses, though it still attracted crooks. The one exception was the Spencer House, a celebrated hotel at the northwest corner of Front and Broadway Streets that in 1866 welcomed President Andrew Johnson with a lavish reception. The hotel was razed in 1935.

The Bottoms was a working-class neighborhood as well, with more reputable businesses and a diverse population of Irish, German, Jewish

and Italian immigrants, as well as Chinese, Japanese and Lebanese, all with their own churches. In 1915, St. Philomena's, a German Catholic church on Pearl Street between Pike and Butler Streets, was struck by lightning, and the steeple fell onto a shoe store. Sadly, few of the churches survive, notably St. Xavier Church at 607 Sycamore Street and Christ Church at 318 East Fourth Street. Historic churches, including Wesley Chapel and Allen Temple, are gone. In 1857, Samuel Clemens, the future Mark Twain, worked as a printer and lived at 76 Walnut Street, now part of Fort Washington Way. Composer Stephen Foster boarded on Fourth Street, east of Broadway, in 1846 while working for his brother's steamboat agency, Irwin & Foster, and writing "Oh! Susanna." Leonard Slye, who would become Roy Rogers, "King of the Cowboys," was born in 1911 on Second Street, between where Great American Ball Park and U.S. Bank Arena sit.

The Bottoms saw a steady decline from the 1870s. Everyone with the economic means to move left the inner city. Many of the Bottoms residents relocated to the West End, and the old neighborhood started to disappear. Warehouses popped up along the riverfront as the area became unlivable. After the devastating 1937 flood, the U.S. Army Corps of Engineers decided

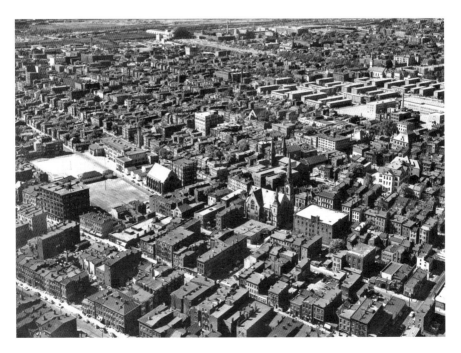

The West End was the city's densest neighborhood. *Courtesy of the* Cincinnati Enquirer/ *Herb Heise.*

that the riverfront area was not worth protecting with a floodwall. The City Planning Commission's *Cincinnati Metropolitan Master Plan* of 1948 outlined a new riverfront with parks, a convention center, apartments and a baseball stadium, as well as an expressway, all south of Third Street. Fort Washington Way opened in 1961, effectively cutting off the Bottoms from the rest of downtown. Much of the riverfront was cleared to build Riverfront Stadium in 1970 and Riverfront Coliseum (U.S. Bank Arena) in 1975. For the city's bicentennial celebration in 1988, the eastern waterfront was made into Sawyer Point. The Banks developments, including Great American Ball Park and numerous restaurants, have revitalized the riverfront with the city's favorite recreations—baseball and beer. Urban residency is trending once again, but it is too early to see if downtown will become an actual neighborhood again.

KENYON-BARR DISTRICT

At the turn of the century, the West End was an enormous neighborhood, spanning the entire area west of Central Avenue to the base of Price Hill, including what today is Queensgate and Lower Price Hill. It is one of the city's oldest neighborhoods as part of the basin where Cincinnati was settled. The lower West End was a mix of African American and Irish, with its own rough "Little Bucktown" section that was not as bad as its progenitor. The upper West End started as an affluent neighborhood where beer barons built mansions on Dayton Street, which was nicknamed "Millionaires' Row." As inclines and electric trolleys allowed the wealthier citizens to climb out of the basin to set up suburban neighborhoods on the hills, middle-class families moved into the upper West End mansions, but the poorer folks had no means to be upwardly mobile. By the 1920s, the majority of the city's African American population still lived in the basin, and the West End became the center of the city's black community. But with poor sanitation and cramped living conditions, the city's densest neighborhood was considered a slum, and the city was all too happy to be rid of it.

In the 1930s, plans for a central railroad station led to the construction of Union Terminal in the West End, further segregating the upper and lower portions of the vast neighborhood. The city wanted the slums cleared out. Two federal housing projects were created to eliminate the squalid conditions and provide low-rent apartments for the poor population in the

West End. Laurel Homes, completed in 1938, provided 1,303 apartments in twenty-nine building units, though it wiped out 1,600 dwellings from that same fifteen-block area. At the time, white residents lived in the apartments north of Armory Street, and black residents lived south of it. Lincoln Court, completed in 1942, was for black residents only, with 1,015 apartments in fifty-three buildings. Laurel Homes had a large playground area, and Lincoln Court included a church and community building. The Cincinnati Metro Housing Authority ran both projects.[94]

The Ohio Redevelopment Act of 1949 gave the city the right to purchase blighted property and clear it for redevelopment. The master plan of 1948 proposed the Mill Creek Expressway, now known as I-75, which would require that a section of the lower West End be cleared. The city used the opportunity to also develop the industrial complex that had been included in the master plan, and entire area was to be cleared. The government named the project Kenyon-Barr after two of the streets involved, so the section of the West End about to be wrecked finally had its own name—the Kenyon-Barr district.

The $44 million renewal project, supported with some federal funds, was viewed favorably for clearing the slums and dressing up the area in the hopes that improved conditions would help keep people living downtown and not fleeing to the suburbs. Reports focused on the conditions of the slums, citing old homes built for a single family that were housing three or four families, as well as high rates of tuberculosis, pneumonia and infant mortality. But it is difficult not to read some racial motivation in the plan, as the Kenyon-Barr district was home to more than ten thousand families, 98 percent of them African American—all of whom would need to find somewhere else to live. "The resulting diaspora was a defining moment for the city," *Enquirer* reporter Gregory Korte wrote later, "forever changing not just that neighborhood, but accelerating the movement of African-Americans into neighborhoods like Avondale and Walnut Hills just as white Cincinnatians were using those newly built highways to move further out of the city."[95] The majority of the displaced African American families moved to Over-the-Rhine and Avondale and continued to struggle economically. This massive upheaval contributed to the racial disparity in the city and the unrest that erupted in Avondale in the late 1960s.

Before the Kenyon-Barr district was torn down, the city had each of the 2,800 buildings photographed while a man stood out front holding a sign with an identifying number. This number included hundreds of shops, churches and commercial and manufacturing facilities. Though this was likely

done for legal reasons, it ended up being an ironic record of a neighborhood that was about to be swept away. The photographs are in the collection of the Cincinnati History Library and Archives. The homes and buildings, along with most of the streets, were razed in 1959, and factories sprang up in their place. The Butternut Bakery plant on West Fifth Street was a holdover from the old West End, having begun in 1912 as a neighborhood bakery. As the bakery grew, it absorbed nearby buildings, including a police station, and when the area was converted to the industrial complex, it became just another factory. An advertising agency hired by the city came up with a new name for the region: Queensgate.

The West End neighborhood remains, albeit much smaller than it was. Dayton Street is listed on the National Register of Historic Places. Though Laurel Homes was also designated a historic district, the designation was lifted so that all but a few of the outdated apartments were razed in 2000 and replaced with a new development, City West. In 2005, a consortium of churches and social service agencies called CityLink wanted to convert an old slaughterhouse on Bank Street into a center for disadvantaged people to receive social services, from job training to drug treatment. Overcoming neighbor complaints and lawsuits over zoning laws, CityLink Center opened in 2012.

In Queensgate, there is nary a sign of the old neighborhood.

20
CHURCHES

Some of the oldest buildings in the city are churches. Old Saint Mary's on Thirteenth Street in Over-the-Rhine, completed in 1842, barely beats out St. Peter in Chains on Plum Street as the oldest one still standing. Perhaps because churches are not as beholden to financial stability or because they serve a sacred function that affords them venerable status, they are more immune to the changing landscape. Whatever the reason, churches survive, sometimes for centuries but not forever. Some deteriorate, some have dwindling congregations and some stand in the way of progress.

Wesley Chapel

Wesley Chapel was perhaps the most historic church in Cincinnati, and certainly the oldest when it was torn down. The Methodist church on the north side of Fifth Street between Broadway and Sycamore Streets was built in 1831, replacing the Old Stone Church, the city's first Methodist church, that occupied that site back in 1806. The small red brick Georgian church was modeled after John Wesley's original Methodist chapel in London though it was much simplified, with six pilasters in the front and three stained-glass windows above the doors as the only exterior decoration. The Wesleyan Chapel, as it was sometimes listed, was a joint Methodist and Episcopal church when it was dedicated on Christmas Day 1831. At that time, it was

the largest church in the city and, with 1,200 seats, the largest meeting place in the West.

The story, often repeated in various sources, that the funeral of President William Henry Harrison was held at Wesley Chapel in 1841 is not true. Upon the president's death on April 4, 1841, the first time a sitting president had died, the funeral was held in the East Room of the White House on April 7, and then Harrison's body was temporarily placed in a public vault in Congressional Cemetery in Washington, D.C. A eulogy for President Harrison was delivered by Edward D. Mansfield at Wesley Chapel on May 14, and perhaps this has been confused for a funeral service. On July 5 of that year, Harrison's remains were transported by steamboat to Cincinnati, where his body was kept at the residence of Colonel W.H.H. Taylor on Sixth Street until July 7, when it was taken by boat to his burial site in North Bend, about thirteen miles downriver from Cincinnati.[96]

Another presidential visit is definitely true. On November 9, 1843, former president John Quincy Adams rode in a carriage as the head of a procession starting at Third Street up the hill of Mount Ida to lay the cornerstone of the Cincinnati Observatory. The weather was unpleasant, so it was determined he would present the speech the next day at Wesley Chapel. Despite its size, there was not enough space for all the audience. People were so taken by Adams's oration, believed to be his last public speech, that a resolution was made for Mount Ida to be renamed Mount Adams in his honor. Upon Adams's death in 1848, a grand funeral was held at Wesley Chapel in memoriam.

Though it was considered large when it was built, Wesley Chapel was dwarfed by the skyscrapers that rose up around it. The congregation that had once numbered two thousand and was the seat of Methodism in Cincinnati had dwindled to just sixty-four members by the 1960s. The Procter & Gamble Company wanted to expand its corporate headquarters on the spot where the Methodists had been meeting since the early nineteenth century, and in 1969, the congregation agreed to sell the old church for $700,000. Two weeks later, the church was added to the National Register of Historic Places. P&G offered to finance relocating the church structure across the street, but there was insufficient community interest in saving the old church. Before the chapel was demolished, a cemetery was rediscovered underneath an annex built in 1859, and the graves were reinterred in the Wesleyan Cemetery on Colerain Avenue in Northside. The city's oldest house of worship was razed in 1972. The next year, the congregation opened a new chapel on East McMicken Avenue in Over-the-Rhine. The small round

The Wesley Chapel, the city's oldest house of worship, attracted little interest in saving it. *Courtesy of the Library of Congress.*

chapel, built of concrete with a conical roof, is an odd design and is very modest, seating just 150 people, though some features from the old building survived, including the stained-glass windows and the stone engraved with the date 1831.

FIRST PRESBYTERIAN CHURCH

The tall spire of First Presbyterian Church was a visible landmark among the cluster of downtown buildings along Fourth Street. The church stood out in other ways as well. As the oldest congregation in the city, its origin goes back to the very first days when settlers landed at Losantiville. In surveyor Israel Ludlow's original plat in January 1789, the lots bounded by Fourth, Fifth, Walnut and Main Streets was designated "for public use" and included a Presbyterian church, as most of the early settlers were of that denomination. The congregation was organized on October 16, 1790, and set up the first church building in the Northwest Territory in 1791,

near Fourth Street, facing Main. The church was "an utterly plain and bare frame building…one story and one room, small square windows and battened doors, and no ornament whatever except a little semi-circle in the front gable above the door."[97] The walls were not lathed or plastered, and there was no ceiling for some time. Boat planks on logs were used as pews, and worshipers sat with rifles between their legs in case of Indian attacks. The first pastor was James Kemper, whose log house built in Walnut Hills in 1804 is one of the oldest homes in Cincinnati and is exhibited at the Heritage Village Museum. In 1797, the church property was acquired from John Cleves Symmes, who owned the territory where Cincinnati was settled, for sixteen dollars, the cost of the land survey. Ludlow, one of the town founders, was buried in a graveyard adjoining the church; a stone marker for Ludlow would follow to each of the congregation's future church buildings. Funds for a new church were collected from such Cincinnati dignitaries as Jacob Burnet, Martin Baum, William Lytle and Nicholas Longworth. The church, completed in 1815, had two square towers with conical roofs, so it was known as "the two-horned church."

Second Presbyterian Church branched off in 1816 and, in 1830, built a Grecian-styled building on the south side of Fourth Street between Vine and Race Streets, later the site of McAlpin's department store. The steeple's clock tower is visible in the famous "Cincinnati Panorama of 1848" daguerreotype by Charles Fontayne and William S. Porter. Research by Cincinnati library director Carl Vitz and Captain Frederick Way in 1947 identified the date of the photograph as the early afternoon of September 24, 1848, but it wasn't until the plates were restored in 2007 that high-resolution digital scans were able to read the time on the church clock: 1:55 p.m.

Dr. Lyman Beecher, a prominent theologian and the father of Harriet Beecher Stowe, was invited to become president of Lane Theological Seminary and pastor of Second Presbyterian Church in 1833, but he fell victim to the internal schism within the Presbyterian Church. Reverend Dr. Joshua Wilson, the Old School minister of First Presbyterian, rejected Beecher's New School theology and charged him with heresy, slander and hypocrisy. Although Wilson later withdrew his objections, Beecher's effectiveness in the church was hampered, and he left Cincinnati in 1843.

In 1851, an elegant new First Presbyterian Church building was constructed on Fourth Street a few spaces west of Main Street, near the spot of the previous churches. A 285-foot Neo-Gothic spire rose above all other buildings, topped with a huge golden hand pointing to heaven. The Gothic style, as well as the height, made the church a unique feature of Fourth

The spire of First Presbyterian Church was noticeable from all over the city before it was crowded by skyscrapers. *Courtesy of the* Cincinnati Enquirer.

Street as the street became the city's financial center and skyscrapers began popping up on it.

In August 1929, First Presbyterian announced that the church would be torn down and replaced with a magnificent forty-story, 470-foot skyscraper

to be called Temple Tower.[98] The announcement came the same day as the unveiling of the plans to build the Carew Tower complex, and the two skyscrapers were to become companions in the Cincinnati skyline. The firm Samuel Hannaford & Sons had drawn up the design in the Art Deco style similar to that of Carew Tower but infused with Gothic elements. The building would have thirty-two floors of offices and an eight-story tower on top with a Gothic cathedral–like steeple that included the hand from the old church pointing heavenward. The church would occupy four stories in the rear. But two months later, the stock market crashed, thrusting the nation into the Great Depression, and the $2.225 million Temple Tower was never built. Instead, in 1933, the First Presbyterian Church building at 142 East Fourth Street was sold to the Hotel Burnet Company, and the congregation voted to merge with the Presbyterian Church of the Covenant, itself a merger of Second Presbyterian Church with two other offshoots. The combined congregation, Covenant-First Presbyterian Church, moved to Covenant's Gothic chapel, built in 1875 at Eighth and Elm Streets. The "Old First" church was demolished in 1936 for a parking lot. Today, the Federal Reserve Bank occupies the site.

Christ Church

A group of citizens held a meeting with Reverend Philander Chase in the home of Dr. Daniel Drake, an eminent physician, on May 18, 1817, to discuss establishing an Episcopal congregation in Cincinnati. Among the attendees was General William Henry Harrison, who became a member of the parish known as Christ Church. The congregation first met in a room in a cotton factory on Lodge Alley between Fifth and Sixth Streets and then in a former Baptist meetinghouse on West Sixth Street, which the church purchased in 1821. Reverend Samuel Johnston resigned in 1828 over the church's failure to pay his salary, and more than half the parishioners joined him to create St. Paul's Episcopal Church.

St. Paul's built a permanent home on East Fourth Street in 1836. The church closed at the end of 1882, and the next week, the congregation united with St. John's Episcopal Church under the name St. Paul. The St. Paul Building (111 East Fourth Street), designed by Samuel Hannaford, replaced the old church in 1884. The former St. John's church at the southeast corner of Seventh and Plum Streets was completed in 1852

and offered a unique Norman design. Square towers on the corners faced out at an angle, and the main entrance was an impressive arch doorway with recessed arches. St. Paul's was the first cathedral of the Diocese of Southern Ohio until 1937, when the church was razed. The Cincinnati Bell annex is on the spot today.

The old Christ Church, built in 1835, was a reproduction of the St. Dunstan's Stepney New Church in London. *Courtesy of the* Cincinnati Enquirer.

In 1835, Christ Church constructed a new church on the north side of Fourth Street between Broadway and Sycamore Streets, a site that has been its location since. The red brick church was a reproduction of the St. Dunstan's Stepney New Church in London in the later pointed architectural style popular in the early nineteenth century. It features two octagonal towers and turrets, pinnacles and transverse windows. The parish house was erected in 1907 by Mary M. Emery in memory of her husband, Thomas J. Emery. The Gothic parish building, also similar to the Stepney church, is in the same red brick as the cathedral with a notable square tower capped with pinnacles. Funerals for William Haines Lytle, the fallen Civil War general, and Nicholas Longworth III, the Speaker of the House, were held at Christ Church. President Herbert Hoover was among the political dignitaries who came to pay their respects to Longworth and his widow, Alice Roosevelt Longworth, the daughter of Theodore Roosevelt.

As other churches moved from downtown to the suburbs, Christ Church remained. In 1940, it held the first Boar's Head Festival, an old English Christmas custom done in period costume that has become a tradition at the church. Age was not kind to the old cathedral, and the 1835 church was torn down in 1955. The new church's first design, by acclaimed Finnish architects Sarrinen & Sarrinen, was in a contemporary style with an asymmetrically placed tower adorned with a crucifix between open grill work.[99] After Eliel Sarrinen's death, Eero Sarrinen refused requests to change his father's design to keep costs down, so he was fired. Architect David Briggs Maxfield of Oxford, Ohio, then designed the contemporary cathedral, which was dedicated on April 14, 1957. His bold, angular church, while using the stained-glass windows from the old cathedral, is rather incongruous with the Gothic style of the parish house. Both are still standing and used today

Rockdale Temple

In 1824, a small group of Jewish men in Cincinnati formed a congregation, KK Bene Israel (the Holy Congregation of the Children of Israel). The congregation's first synagogue was built at Sixth and Broadway Streets in 1836 but was replaced with another on the same site in 1852. As the Jewish community expanded, it needed more space. In 1869, KK Bene Israel constructed a grand Moorish-style temple with Ionic towers at Eighth and Mound Streets in the West End and sold its building on Broadway to the

Allen Temple AME Church. When Rabbi Isaac Mayer Wise started the Hebrew Union College–Jewish Institute of Religion in 1875, the first classes met in the basement of the Mound Street synagogue.

In 1906, KK Bene Israel moved again to the southeast corner of Rockdale and Harvey Avenues in Avondale, giving the congregation the name it is currently known by, Rockdale Temple. The temple, designed by Rudolph Tietig of the Cincinnati firm Tietig and Lee, was a Neoclassical design with Corinthian columns on the front and rows of tall, arched stained-glass windows on the sides. Rockdale Temple was dedicated on September 14, 1906. The poet Robert Frost, a longtime friend of Rabbi Victor E. Reichert, delivered a sermon there in 1946.

Avondale is a predominantly African American neighborhood, and the intersection of Rockdale Avenue and Reading Road, about two blocks from the temple, was the epicenter of race riots in 1967 and 1968 that caused millions of dollars in property damage. The congregation moved to its current synagogue on Ridge Road in Amberley Village in 1969, though it

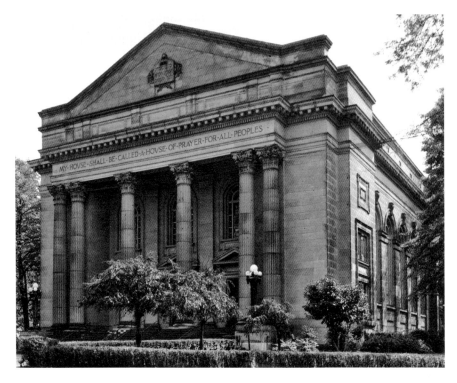

The Neoclassical Rockdale Temple synagogue derived its name from Rockdale Avenue in Avondale. *Courtesy of the* Cincinnati Enquirer/*Allan Kain.*

continues to use the Rockdale Temple name. To dedicate the new synagogue, jazz musician Dave Brubeck premiered his cantata *The Gates of Justice*, a call for brotherhood between black and Jewish people in the wake of racial tension. The old temple was torn down in the 1970s. Today, the site is a community playground.

ALLEN TEMPLE AME CHURCH

The Allen Temple AME Church is the oldest African Methodist Episcopal (AME) church in Ohio. African Americans in Cincinnati had been worshipping at white Methodist Episcopal churches but were discriminated against, so they founded their own AME congregation in 1824. They met at several buildings around Sixth and Broadway Streets in the black district known as Bucktown under names like Little Red Church on the Green, Old Lime House, Bethel Creek and Allen Chapel, named for Reverend Richard Allen, who established AME in Philadelphia in 1787. Allen Chapel served as a safe haven for runaway slaves as a station on the Underground Railroad.

In 1870, the congregation purchased the KK Bene Israel synagogue at 538 Broadway Street and christened it Allen Temple. The Moorish-styled building had a trio of minarets at each corner with the parapet a series of bell-like arches. The windows continued the bell-arch motif. The church housed Allen Temple for over a century until the congregation moved to Reading Road in Roselawn in 1979. Like Wesley Chapel, the old building was razed in 1982 to make way for the expansion of P&G's headquarters.

CINCINNATI WORKHOUSE

A jail may seem an odd building for people to lament losing, but the Cincinnati Workhouse was no ordinary jail. As one of the earliest designs of famed Cincinnati architect Samuel Hannaford, it had historic value even as it aged to become unfit for its intended purpose. The Workhouse was a formidable design, often compared to a fortress or a medieval castle, and was laid out more like a penitentiary than a city jail.

Shortly after the Civil War, the city commissioned a jail workhouse to be built on six acres on Colerain Avenue in Camp Washington at the former site of a Mexican War military training camp that gave the neighborhood its name. The massive structure, 510 feet long, had a five-story central cellblock with a north wing to hold the men and a south wing for the women. Each end had a quartet of imposing towers, carrying the impression of a castle to the fullest. The middle building for the superintendent had an attractive mansard roof and cupola. The Workhouse, the first major work of Hannaford's career, was meant to be admired.

The Workhouse opened in 1869 with 606 cells and, by the turn of the century, averaged three thousand prisoners a year, mostly for petty crimes like prostitution, drunkenness and vagrancy. It was a workhouse where prisoners did labor, construction, clothing manufacturing and, later, car repair. It was considered a model jail for many years because of its progressive prison reform practices, including a welfare department with social workers and vocational programs. The jail closed in 1920 but was reopened right away by Hamilton County as the Community Correctional Institution, though most people still called it the Workhouse.

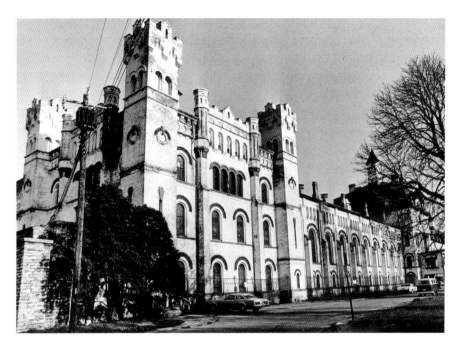

The castle-like Cincinnati Workhouse didn't change much between the Civil War and its demolition in 1990, and its conditions made it unsuitable for habitation. *Courtesy of the Cincinnati Enquirer.*

By the 1960s, the Workhouse's conditions had not really changed—it was still much like a Civil War–era jail. Many cells did not have plumbing or lighting, heating and cooling systems were nonexistent, there was no way to segregate the first-time offenders from the old-timers and there wasn't enough work to keep the prisoners busy. Complaints and lawsuits plagued the Workhouse over the nasty conditions and prisoner treatment, and after decades of problems, a judge ruled in 1976 that "it was cruel and unusual punishment to confine anybody in that institution,"[100] though it took until 1985 to finally close it. Prison scenes for the films *An Innocent Man* (filmed as *Hard Rain*) starring Tom Selleck and *Tango & Cash* with Sylvester Stallone and Kurt Russell were filmed on location at the Workhouse because it looked so scary and decrepit. When demolition began in 1990, most city officials applauded, though there was an effort by the Miami Purchase Association for Historic Preservation (now Cincinnati Preservation Association) to save some elements, including the yard bell, the door of a jail cell and a prisoner registry, which are on display at the Hamilton County Justice Center on Sycamore Street.

SAMUEL HANNAFORD

Hannaford was born in Devonshire, England, in 1835. His family immigrated to America when he was nine years old and purchased a farm in Cheviot. Hannaford attended Farmer's College in College Hill and apprenticed with architect John R. Hamilton. In 1858, he joined Edwin Anderson; during their partnership, Anderson & Hannaford designed the Cincinnati Workhouse. After the firm split in 1870, Hannaford worked on his own and with various partners, most notably as the firm Samuel Hannaford & Sons, which continued after his passing.

Hannaford is credited with much of the architectural feel of Cincinnati, as he was the designer of several of the most famous landmarks, notably Music Hall (1878) and Cincinnati City Hall (1893). Hannaford designed more than three hundred buildings— most of them in the Tristate area—and partly because of admiration for his designs, a high number of them still exist: Old St. George Church (1872), Clifton Heights (the steeples of the former Catholic church partially collapsed in a fire in 2008); Cincinnati Observatory (1873), Mount Lookout; the Palace Hotel (now the Cincinnatian Hotel) (1882), Sixth and Vine Streets; Van Wormer Library (1901) at the University of Cincinnati, the oldest surviving building on the UC campus; and the Winton Place Methodist Episcopal Church (1884), where Hannaford was a member and where his funeral was held.

Hannaford died in 1911 and was buried in Spring Grove Cemetery. His sons continued the firm of Samuel Hannaford & Sons and designed many other notable buildings, including the Emery Theatre, Cincinnati General Hospital, the Dalton Avenue U.S. Post Office and the Times-Star Building. In 1980, a collection of Hannaford's buildings was added to the National Register of Historic Places, including the Workhouse, though the designation did not save it from demolition. Other Hannaford designs have been torn down, but more survive than those of some of his rivals, such as James W. McLaughlin.

Samuel Hannaford & Sons won the design competition in 1891 to build the Odd Fellows Temple at the northwest corner of Seventh and Elm Streets, the site of the former home of Judge Jacob Burnet. The seven-story Gothic building, dedicated on May 15, 1894, was home to the local lodge of the Independent Order of Odd Fellows, a fraternal organization based on an English fraternity founded in the eighteenth century that assisted widows and orphans. Welfare programs established by the New Deal led to a drop in membership, and the Odd Fellows are not as visible these days. The Odd Fellows Temple was razed in the 1940s.

The Ohio National Guard Armory was another fortress-like construction, this one thematically tied to its use as the headquarters for the First Regiment of the Ohio National Guard. The three-story armory, built in 1889, was distinguished by Hannaford's use of Gothic and Romanesque details, including a battlement tower, in a functional building. It was a landmark in the West End until the construction of

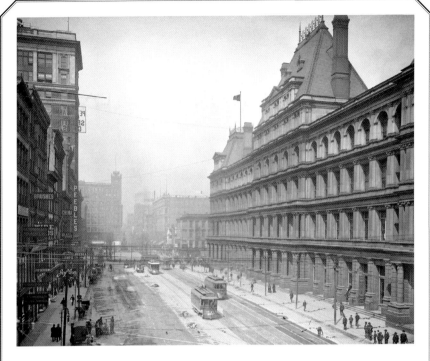

Samuel Hannaford was the supervising architect for the U.S. Post Office and Custom House on Government Square (right). *Courtesy of the Library of Congress/Detroit Publishing Company.*

I-75 cut it off from the neighborhood. Being on the National Register did not help the armory, either, and it was destroyed in 1984.

Hannaford was not the designer of the U.S. Post Office and Custom House on Government Square, at Fifth Street between Walnut and Main, but he was the supervising architect in 1874. Alfred B. Mullett was the architect of the four-story French Renaissance building with towers and a varied roofline. Inside, it was basically a hollow square with a massive skylight surrounded by rooms for the post office, government office and customhouse. The large government building was a replacement for the old post office at Fourth and Vine Streets, a Roman Corinthian–style building that was inadequate for the volume of mail handled in the city. After eleven years of construction, the Government Building, as the new post office was sometimes called, finally opened in April 1885. The building was insufficient to accommodate the growth of federal government services, and it was demolished in November 1936 to be replaced in 1939 by the Art Moderne government building known today as the Potter Stewart United States Courthouse. The main post office later relocated to the Dalton Avenue location, an Art Deco building designed by the Hannaford & Sons firm in 1933.

OLD MAIN LIBRARY

Of all the buildings Cincinnati has lost, the most bemoaned are the Albee Theater and the Old Main Library. Photographs of the cast-iron book alcoves and spiral staircases usually elicit the same response: How could the city have been so shortsighted as to let this gem go? But the Main Library, which became Old Main when the replacement was built, was torn down without a whimper in 1955. The original library building stood for eighty-five years at 629 Vine Street, next door to the old Cincinnati Enquirer Building. Once heralded as "the most magnificent public library in the country,"[101] in the end, Old Main was derided as antiquated and unsuitable for the library's needs.

The public library's history began on March 14, 1853, when the Ohio Common Schools Act allowed funds to be collected for school libraries. School board president Rufus King, the library founder, created a central library in an office of the Central School on Longworth Street between Race and Vine Streets, north of Fifth. In 1856, Dr. Cornelius G. Comegys, a member of the library committee, made a deal to move the library to the second floor of Greenwood Hall, home of the Ohio Mechanics' Institute (OMI), a technical school at the southwest corner of Sixth and Vine Streets. The library merged its collection with OMI's. In 1865, Thomas Edison, then eighteen years old, spent a year in Cincinnati as a telegraph operator. When he wasn't working, Edison read every book he could find on electricity at the OMI library,[102] which at that time was a joint OMI/public library. The library outgrew Greenwood Hall, and in 1867, King finally got the authority to levy a public library tax, which could pay for a new building.

He became president of the library board, and the Ohio School Library became the Public Library of Cincinnati.

In 1866, Truman B. Handy, a frequent millionaire and ex-millionaire, announced plans to build the Handy Opera House on Vine Street between Sixth and Seventh Streets to compete with Pike's Opera House. Architect James W. McLaughlin planned a four-story building with the opera house on the ground floor and an attached building for an art studio and gallery.[103] But Handy's money dried up, and only the front building was nearly complete when the board of education purchased the opera house and the land for $83,000 in September 1868. The board hired McLaughlin for $10,965 to complete the project but as a library instead of an opera house. William Frederick Poole, the prominent librarian of the Boston Athenaeum, was hired as Cincinnati's first real librarian the next year and brought his own ideas of a modern library. The public library actually consisted of three buildings. The front building, which was the original opera house, was opened to the public on December 9, 1870. The middle building and main hall opened to great fanfare on February 25, 1874, with a speech by George Hunt Pendleton, a former U.S. representative and the Democratic candidate for vice president in 1864. The total cost of the lot and building was $383,594.53.

Patrons entered on Vine Street beneath busts of William Shakespeare, John Milton and Benjamin Franklin. In later years, the words "PUBLIC LIBRARY" would be spelled out in light bulbs. The lobby had offices on the sides and a charging desk booth in the center. The floor was white marble and black and red slate checkerboard tile throughout. The three levels above housed the special topics and children's library. Through the lobby was the vestibule, the three-story connecting building with steps that led to the main hall. It was like stepping into a cathedral. The main hall was stunning, an open well four stories tall with five levels of cast-iron book alcoves standing like dominos along the edges. Spiral staircases provided librarian access to the upper shelves with iron walkways at each level. The ceiling, supported by cantilever-type beams, topped off the hall with a massive glass skylight. Shafts of sunlight cut through the windows to provide ample illumination. The *Enquirer* described the main hall:

> *The main hall of the building is a splendid work…The hollow square within the columns is lighted by an arched clear roof of prismatic glass set in iron, the light of which is broken and softened by a paneled ceiling of richly-colored glass…One is impressed not only with the magnitude and beauty of the interior, but with its adaptation to the purpose it is to serve.*[104]

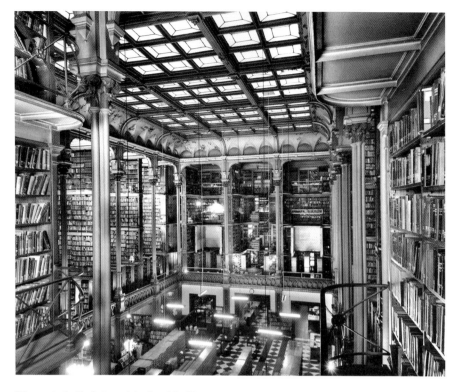

The main hall of the original public library was like no other, integrating the vertical lines of the books themselves in the design, all beneath an enormous skylight. *From the Collection of the Public Library of Cincinnati and Hamilton County.*

A visitor praised the library in 1877: "This is the real diadem of the Queen of the West...Cincinnati, of *all* the cities of the West, may boast of having the richest, the best arranged, and the most generally useful library."[105] This was all part of Poole's vision for libraries—to appeal not just to scholars but also to the public. He added more fiction and even handed out library cards to children. He controversially opened the library on Sundays. But when the completed public library opened in 1874, Poole had already left. What he began in Cincinnati he continued as the librarian at the Chicago Public Library. His plans for the Cincinnati library became the Cincinnati-Chicago Model for modern public libraries.

The public library contained 60,000 volumes when it opened with an estimated capacity of 300,000. That wouldn't be enough space for long. By 1900, the library was bursting at the seams, so library trustee James Albert Green visited Andrew Carnegie in New York to ask for funding for a new

building. Carnegie believed that a free library was the best gift he could give a community, provided that the community accepted and maintained it. That was his standard deal: If a town would provide the site and upkeep, he'd fund the building of the library. When Green made his plea, Carnegie wrote back, "I do not consider a grand central building as important as the six Branches you speak of" and offered "to furnish the sum needed for the buildings."[106]

The library built nine branches with Carnegie's donation. The first Carnegie library in Cincinnati opened in Walnut Hills in 1906. Branches for the East End, Norwood, North Cincinnati (Corryville), Cumminsville (Northside), Price Hill, Hyde Park, Avondale and the West End followed. Designs were by local architects like Samuel Hannaford & Sons and Garber & Woodward, as well as Edward J. Tilton of New York. At this time, the downtown library became the Main Library. The branch system became the library's focus, eventually expanding to forty branches all over Hamilton County in addition to the Main Library. A few of the Carnegie libraries have been lost as well. The West End branch, situated at the base of the Price Hill Incline, closed in 1947 shortly after the incline ceased operation, and it is the only one to have been demolished. The East End library closed in 1959 and is currently the Carnegie Center of Columbia-Tusculum, a community center. Several of the libraries have been renovated, though none quite as much as Hyde Park. A complete overhaul of Tilton's original design replaced the ornate façade with a simpler modern appearance in 1970. It doesn't even look like the same building.

The lack of space wasn't the only complaint about the Main Library. The building was designed more for aesthetics than for practicality. Only a few years after the library opened, librarian Albert W. Whelpley wrote:

> *Magnificent in its proportions and imposing in appearance, our main hall, by its great waste of space, its utter lack of modern facilities and its many seriously objectionable features, approaches near to being a failure in many important ways…*[T]*he attendants must necessarily ascend and descend numerous flights of iron stairs a number of times each day and evening in search of books and papers in the upper alcoves.*[107]

By the 1920s, the public was calling for a new main library building. A library that could hold 300,000 volumes then housed 1.25 million. Books were stacked horizontally on top of the rows of books and crammed into nooks and crannies or on shelves beyond reach. The library was built for storing books, not lending them out. An annex across College Street behind

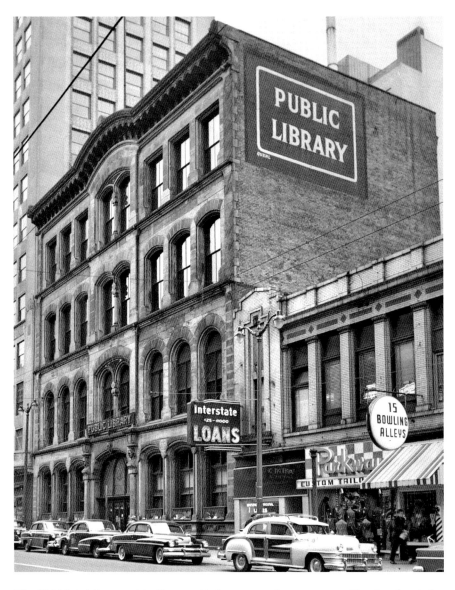

The Old Main Library, originally meant to be an opera house, was considered antiquated in 1953. The author busts around the entrance were some of the few things saved from Old Main. *Courtesy of the* Cincinnati Enquirer/*Bob Free.*

the library (between Vine and Race Streets) held the overflow of materials. Even when the library was new, the *Commercial* was critical: [I]t is exceedingly doubtful whether the civilized world holds in its bosom a single public building which is so poorly ventilated as the Cincinnati Public Library."[108]

Decades later, the luster had worn off the beautiful main hall. The paint was peeling. The library was a vertical space with no room to grow. Green, the president of the library's board of trustees for over fifty years, called the library building "a constant humiliation."[109]

The library floated bond issues for a new library in the 1920s and 1930s, but all were defeated until one finally passed in 1944. A new library would be built, one that, it was hoped, would have a horizontal layout for more space. Postwar inflation and squabbles over the location for the site dragged on. The intersection of Fourth and Main Streets was recommended by the City Planning Commission, but opposing camps, believing that the city would grow northward, wanted something farther north, at the northeast corner of Central Parkway and Vine Street. Rebuilding on the Old Main site was even considered, but the popular choice was the southwest corner of Eighth and Vine Streets, which the board of trustees purchased from the Huenefeld Company in 1949 for $1.25 million.

The doors of Old Main closed on January 27, 1955, and the new Main opened four days later on January 31. One thousand dollies, each carrying 150 to 250 books, were wheeled through windows to steel-framed temporary elevators that lowered the dollies to street level. The books were then loaded up on trucks for the move. UC students formed a human chain up Vine Street passing books the block and a half from building to building.

The new red brick and granite building designed by Cincinnati architect Woodie Garber, the son of Frederick W. Garber of Garber & Woodward, was praised for its contemporary style and as one of the most modern libraries in the country. The building was dedicated as a war memorial to those from Hamilton County who had died during World War I, World War II and the Korean War. The 1955 library was only a fraction of its current size, with the entrance on Eighth Street looking something like a department-store entrance. The fact that the library was situated next to the Gayety Burlesk, a strip club, made some uncomfortable. In 1982, the library remodel more than doubled the size of the building, filling the entire block. The expansion featured an atrium and a skylight, perhaps in homage to the main hall of the original library. In 1997, a north building was added on the next block, accessed by a walkway across Ninth Street.

As for Old Main, the building was sold to the Leyman Corporation, fated to be razed for an office building and parking garage. Tiles and fixtures were snatched up by lovers of the library or people wanting to repurpose the materials. Librarian Carl Vitz purged most of the library's art, including several busts of notable Cincinnatians and a replica of the Rosetta Stone.

Only the three author carvings from the entrance, a bust of thespian James E. Murdock and a few of the circular stained-glass windows were saved and carried over to the new building.

When the end came for Old Main, there were no arguments to save it. No one organized protests or campaigns. The interest in the building today reflects current tastes and romance with the past, not the reality at the time. But as John Fleischman noted in his chronicle of the library, "Yet when the doors closed forever…and wise heads declared that Old Main would never be missed, they were wrong."[110]

AFTERWORD

The folks at the Cincinnati Museum Center have assembled "Cincinnati in Motion," a fantastic 1:64-scale model of the Queen City through the decades of the 1900s through the 1940s that re-creates much of the lost Cincinnati. Long-lost landmarks are reborn, the streetcars and inclines actually run and Crosley Field lights up for a night game. The model perfectly illustrates that our history can be mourned for what has been lost and, more importantly, celebrated for what was. There are dozens of other now-gone theaters, hotels, churches and buildings that helped to forge Cincinnati's identity. Some of them were unheralded and unnoticed as they faded away. But each of them has a story if we know where to look. It's up to us all to remember.

NOTES

CHAPTER 1

1. Conteur, "Fire at First Pike's Opera House," *Cincinnati Enquirer* (hereafter cited as *Enquirer*), March 20, 1921.
2. For a more detailed description, see Kenny, *Illustrated Cincinnati*, 37.

CHAPTER 2

3. Judge Jacob Burnet is quoted in Ford and Ford, *History of Hamilton County, Ohio*, 232.
4. *Enquirer*, "Disastrous Fire," July 10, 1849.
5. Ibid., "College of Murder," March 9, 1884.
6. Ibid., "He Escapes the Gallows," March 25, 1884.
7. Ibid.
8. Ibid., March 29, 1884.
9. Ibid., March 30, 1884.
10. Ibid.

CHAPTER 3

11. O'Gorman, *Three American Architects*, xv.
12. *Richardson*, 56–57, quoting an extract of Richardson's proposal.
13. Ibid., 59.
14. *Enquirer*, "An Architectural Wonder," January 29, 1889.
15. Hitchcock, *Architecture of H.H. Richardson*, 281.

Chapter 4

16. Adams, *Memoirs of John Quincy Adams*, 418–20.
17. As quoted in Singer, *Cincinnati Subway*, 18.
18. *Park System for the City of Cincinnati*, 33.

Chapter 5

19. Goss, *Cincinnati*, 1:300, quoting reporter Lincoln Steffens.
20. Singer, *Cincinnati Subway*, 36–37.
21. Ibid., 117.

Chapter 6

22. *Enquirer*, "The Inclined Plane Railway; Where It Is, and How It Works," May 13, 1872.
23. Ibid., "Death, Sudden and in Awful Shape, Swoops Down Upon the City," October 16, 1889.

Chapter 7

24. "Union Depot at Cincinnati," *Railroad Gazette* 5:8 (February 22, 1873). As quoted in Condit, *Railroad and the City*, 83.
25. This remnant was identified on the blog Digging Cincinnati.
26. Kenny, *Illustrated Cincinnati*, 125–27.
27. Cliff Radel, "Union Terminal Map Mural Clocks Found, Still Marking Time," *Enquirer*, November 2, 2014.

Chapter 8

28. *New York Times*, "How Cincinnati Beer Is Drunk at Home," August 5, 1879.
29. Kenny, *Illustrated Guide to Cincinnati*, 60; *Publications of the American Statistical Association*, 284. The adult male population of Cincinnati in 1890 was 81,100.

Chapter 9

30. *Enquirer*, "Fountain Theater and Hotel to Be Completed Next Year; Photoplay Palace Is to Occupy Site on Fifth Street," April 18, 1926.
31. Ibid., "Palatial New Albee Theater, Opened Without Formalities, Is Model, Modern Playhouse," December 25, 1927.

32. Barbara Jo Foreman, "That Palace on Fifth Street," *Enquirer Magazine*, March 9, 1975. Foreman was a graduate student in art history at the University of Cincinnati at the time.
33. Review of opening night, *Cincinnati Post* (hereafter cited as *Post*), 1927, as quoted in Foreman, "That Palace on Fifth Street."
34. Ohio Valley Chapter of the American Theater Organ Society.
35. *Enquirer*, "Albee Theater Now National Landmark," August 9, 1972.
36. William Lawless Jones, "'Tear It Down,'" *Enquirer Magazine*, March 9, 1975.
37. "The Grand Opera House," *Architects' and Builders' Magazine* 5, no. 5 (January 1904).
38. *Enquirer*, "Family Theater Ready," February 19, 1911.
39. Ibid., "Triumph of the Young Men's Christian Association," November 23, 1891.
40. Ibid., "Y.M.C.A. to Seek New Home," April 8, 1914.
41. Woellert, *Authentic History of Cincinnati Chili*, 25.
42. Jim Rohrer, "Cincinnati Burlesque House Sendoff Was a 2-Night Affair," *Enquirer*, January 3, 2011.
43. Ibid.

CHAPTER 10

44. *Enquirer*, "Base Ball," October 2, 1866.
45. Rhodes and Erardi, *Cincinnati's Crosley Field*, 16.
46. Ibid., 28.
47. Newspapers reported Harry Hake working on an expansion of the stands and new entrance for the 1903 season, but the Palace of the Fans is not included in lists of Hake's designs.
48. Rhodes and Erardi, 4. Joe Nuxhall introduction.
49. John Erardi, "Take Me Out to the (New) Ballpark," *Enquirer*, April 1, 2001.

CHAPTER 11

50. *Enquirer*, "Cincinnati's Coney Island—Opening of the New and Beautiful Ohio Park—A Future Great Resort," June 22, 1886.
51. Anderson, *Ferris Wheels*, 197.
52. *Enquirer*, "Jolly Elks and Their Ladies Enjoy a Most Delightful River Outing," August 25, 1896.
53. Ibid., "The Queen Is Ready," June 6, 1896.
54. Gilbert Love, *Pittsburgh Press*, September 9, 1947; quoted in Jacques, *Cincinnati's Coney Island*, 123.
55. Owen Findsen, "Island Queen the Essence of Summer," *Enquirer*, September 7, 1997.
56. Tom McElfresh, "Good-By, Coney: It's Last Season," *Enquirer*, May 16, 1971.
57. Kings Island.

CHAPTER 12

58. *Enquirer*, August 4, 1895.

59. Wimberg, *Amusement Parks*, 55.

60. *Enquirer*, "Havoc Wrought by Flames in Chester Park and Big Lumber Yards," August 15, 1911.

61. Pete Gianutsos, "'Those Used to Be Fun Days,'" *Post*, December 8, 1976.

CHAPTER 13

62. Helen Heineman in 1979 article of *Harvard Magazine*, as quoted in Jane Durrell, "Frances, We Didn't Understand You," *Cincinnati Magazine*, October 1979.

63. Descriptions of Trollope's Bazaar are found in J. Roger Newstedt, "Mrs. Frances Trollope in Cincinnati: The 'Infernal Regions' and the Bizarre Bazaar, 1828–1830," *Queen City Heritage* 57, no. 4 (Winter 1999): 37–45; *Cincinnati Chronicle*, as quoted in Trollope, *Domestic Manners*, xli–xliv.

64. Trollope, *Domestic Manners*, xlv.

65. Carl Abbott, "The Location and External Appearance of Mrs. Trollope's Bazaar," *Journal of the Society of Architectural Historians* 29 (1970): 257–59.

66. Trollope, *Domestic Manners*, 74.

67. Ibid., 88–89.

68. Conway, *Autobiography, Memories and Experiences*, 230.

69. *Enquirer*, "A Land-Mark Gone: 'Madame Trollope's Folly,' on Third Street, Torn Down," February 13, 1881.

CHAPTER 14

70. Want ad for a "compositor or foreman" for W.A. Crane, Peebles' Corner, Walnut Hills, *Enquirer*, December 20, 1883, p. 3, col. 4.

CHAPTER 15

71. Charles Mackay, "Transatlantic Sketches: The Queen City of the West," January 27, 1858, published in *Illustrated London News*, March 20, 1858, no. 909: 297; *Illustrated London News*, "The Burnet House, Cincinnati," February 26, 1859, no. 961: 203. The journal also called the Burnet House "one of the most magnificent buildings of the kind in the Union."

72. Clubbe, *Cincinnati Observed*, 117.

73. Denys P. Myers, "Isaiah Rogers in Cincinnati: Architect for the Burnet House," *Bulletin of the Historical and Philosophical Society of Ohio* 9, no. 2 (April 1951): 123–24.

74. Cist, *Sketches and Statistics*, 164.

75. *Enquirer*, "The Burnet House: Interesting History of This Famous Hotel," September 2, 1882.

76. *Cincinnati Daily Gazette*, February 13, 1861.
77. *Enquirer*, "Generals in Cincinnati," March 22, 1864.
78. Bowman and Irwin, *Sherman and His Campaign*, 168.
79. *Enquirer*, "Reception of Major-General Sherman—An Immense Demonstration—Enthusiasm of the People," July 1, 1865.
80. *Cincinnati Daily Atlas*, 1849, as quoted in *Enquirer*, "Hotel to Mark Ninetieth Anniversary; Early Days of Gibson House Recalled," February 15, 1939.
81. Kenny, *Illustrated Cincinnati*, 26.

CHAPTER 16

82. As quoted in Poole, *Tyler Davidson Fountain*, 35.
83. Henry Probasco to Mayor Charles F. Wilstach, February 15, 1867, proposing the fountain, in Rogers, *Fountain Square and the Genius of Water*, 36.
84. *The Tyler Davidson Fountain Conservation Appraisal*, 5.
85. *New York Times*, "Cincinnati Civic Atrium Assailed as Vapid Space," January 2, 1983.

CHAPTER 17

86. *Enquirer*, "Splendor and Progress," November 18, 1962.
87. Painter, *Architecture in Cincinnati*, 34.

CHAPTER 18

88. Hurd, *History and Genealogy*, 101.
89. Foreman, *CCM 125*, 41; James Devane, "Old Cincinnati Houses: Shillito Mansion's Days Numbered," *Enquirer*, June 3, 1962.
90. Cliff Radel, "Gamble House Fate Is at Hand," *Enquirer*, March 30, 2013.

CHAPTER 19

91. *Cincinnati Commercial* (hereafter cited as *Commercial*), "Pariah People. Outcast Life by Night in the East End. The Underground Dens of Bucktown and the People Who Live in Them," August 22, 1875.
92. Dabney, *Cincinnati's Colored Citizens*, 156–57.
93. *WPA Guide to Cincinnati*, 149.
94. Ibid., 132, 228–30.
95. Gregory Korte, "Cincinnati's Lost Neighborhood Found," *Enquirer*, June 13, 2010.

CHAPTER 20

96. Reverend Edward S. Lewis, "The Death and Funeral of President William Henry Harrison," *Ohio Archaeological and Historical Publications*, no. 37 (1928).

97. Ford and Ford, *History of Cincinnati, Ohio*, 148.

98. *Enquirer*, "Great Structure Is to Rise on Fourth Street Church Site; Edifice Is to Be 40 Stories," August 25, 1929.

99. Pelkonen and Albrecht, *Eero Saarinen*, 154.

CHAPTER 21

100. *New York Times*, "1866 Jail in Cincinnati Is Shut After Decade of Court Fights," September 17, 1985.

CHAPTER 22

101. www.cincinnatilibrary.org/main/building.asp.

102. Israel, *Edison*, 28, 37.

103. *Enquirer*, "The Proposed New Opera-house and Art Gallery," June 14, 1866.

104. *Enquirer*, "The Public Library," February 26, 1874.

105. Dr. C.L. Bernays to *Cincinnati Volksfreund*, December 8, 1877, as quoted in *Decline & Fall*, 7–8.

106. Andrew Carnegie to James A. Green, April 9, 1902, reprinted in Fleischman, *Free & Public*, 98.

107. An 1890 report by A.W. Whelpley, quoted in *Annual Reports of the Librarian*, 58.

108. *Commercial*, July 12, 1877, as reported in Fleischman, *Free & Public*, 21.

109. As quoted in *Post*, "City Urged to Go Ahead with Library," March 14, 1949.

110. Fleischman, *Free & Public*, 51.

BIBLIOGRAPHY

Adams, John Quincy. *Memoirs of John Quincy Adams*. Vol. 11. Edited by Charles Francis Adams. Philadelphia: J.B. Lippincott & Co., 1876.

Anderson, Norman D. *Ferris Wheels: An Illustrated History*. Bowling Green, OH: Bowling Green State University Popular Press, 1993.

Annual Reports of the Librarian and Treasurer of the Public Library of Cincinnati for the Year Ending June 30, 1892. Cincinnati, OH: McDonald and Eick, 1892.

Bowman, Colonel S.M., and Lieutenant Colonel R.B. Irwin. *Sherman and His Campaigns*. New York: Charles B. Richardson, 1865.

Cincinnati Illustrated Business Directory and Picturesque. Cincinnati, OH: Spencer & Craig Printing Works, 1882–1902.

Cincinnati Metropolitan Master Plan. Cincinnati, OH: Cincinnati City Planning Commission, 1948.

Cist, Charles. *Sketches and Statistics of Cincinnati in 1851*. Cincinnati, OH: William H. Moore & Co., 1851.

Clubbe, John. *Cincinnati Observed: Architecture and History*. Columbus: Ohio State University Press, 1992.

Condit, Carl W. *The Railroad and the City: A Technological and Urbanistic History of Cincinnati*. Columbus: Ohio State University Press, 1977.

Conway, Moncure Daniel. *Autobiography, Memories and Experiences of Moncure Daniel Conway*. London: Cassel and Company, Ltd., 1904.

Cook, William A. *King of the Bootleggers: A Biography of George Remus*. Jefferson, NC: McFarland & Co., Inc., 2008.

Dabney, W.P. *Cincinnati's Colored Citizens*. Cincinnati, OH: Dabney Publishing Co., 1926.

Davis, John Emmeus. *Contested Ground: Collective Action and the Urban Neighborhood*. Ithaca, NY: Cornell University Press, 1991.

The Decline & Fall of the Cincinnati Public Library. Cincinnati, OH: Committee of Citizens, 1886.

Fleischman, John. *Free & Public: One Hundred and Fifty Years at the Public Library of Cincinnati & Hamilton County 1853–2003*. Wilmington, OH: Orange Frazer Press, 2003.

BIBLIOGRAPHY

Ford, Henry A., and Kate B. Ford. *History of Cincinnati, Ohio.* Cincinnati, OH: L.A. Williams & Co., 1881.

———. *History of Hamilton County, Ohio.* Cincinnati, OH: L.A. Williams & Co., 1881.

Foreman, B.J. *CCM 125: University of Cincinnati College–Conservatory of Music 1867–1992.* Cincinnati, OH: University of Cincinnati, 1992.

Giglierano, Geoffrey J., Deborah A. Overmyer and Frederic L. Propas. *The Bicentennial Guide to Greater Cincinnati: A Portrait of Two Hundred Years.* Cincinnati, OH: Cincinnati Historical Society, 1988.

Goss, Charles Frederic. *Cincinnati: The Queen City: 1788–1912.* Vols. 1–2. Chicago: S.J. Clarke Publishing Co., 1912.

Greve, Charles Theodore. *Centennial History of Cincinnati and Representative Citizens.* Vols. 1–2. Chicago: Biographical Publishing Co., 1904.

Hearn, Lafcadio. *Period of the Gruesome: Selected Cincinnati Journalism of Lafcadio Hearn.* Edited by Jon Christopher Hughes. Lanham, MD: University Press of America, 1990.

History of Cincinnati and Hamilton County, Ohio. Cincinnati, OH: S.B. Nelson & Co., 1894.

Hitchcock, Henry-Russell. *The Architecture of H.H. Richardson and His Times.* Cambridge, MA: MIT Press, 1936.

Holian, Timothy J. *Over the Barrel: The Brewing History and Beer Culture of Cincinnati.* Vols. 1–2. St. Joseph, MO: Sudhaus Press, 2000, 2001.

Hotchkiss, Julie, and Joyce Meyer. *Remembering Remus in Price Hill.* Cincinnati, OH: Edgecliff Press, 2011.

Hurd, Dena D. *A History and Genealogy of the Family of Hurd in the United States.* New York, 1910.

Israel, Paul. *Edison: A Life of Invention.* New York: John Wiley & Sons, 1998.

Jacques, Charles J., Jr. *Cincinnati's Coney Island: America's Finest Amusement Park.* Jefferson, OH: Amusement Park Journal, 2002.

Kenny, D.J. *Illustrated Cincinnati: A Pictorial Hand-Book of the Queen City.* Cincinnati, OH: George E. Stevens & Co., 1875.

———. *Illustrated Guide to Cincinnati and the World's Columbian Exposition.* St. Louis, MO: Robert Clarke & Co., 1893.

Mecklenborg, Jacob R. *Cincinnati's Incomplete Subway: The Complete History.* Charleston, SC: The History Press, 2010.

Miller, Zane L. *Boss Cox's Cincinnati.* Chicago: University of Chicago Press, 1968.

Morgan, Michael D. *Over-the-Rhine: When Beer Was King.* Charleston, SC: The History Press, 2010.

Musson, Robert A. *Brewing Beer in the Queen City.* Vols. 1–5. Medina, OH: Zepp Publications, 2012, 2014.

Official Guide of the Centennial Exposition of the Ohio Valley and Central States. Cincinnati, OH: John F.C. Mullen, 1888.

O'Gorman, James F. *Three American Architects: Richardson, Sullivan, and Wright, 1865–1915.* Chicago: University of Chicago Press, 1991.

150 Years of Presbyterianism in the Ohio Valley, 1790–1940. Cincinnati, OH: Committee on History of the Cincinnati Presbytery, 1941.

Painter, Sue Ann. *Architecture in Cincinnati: An Illustrated History of Designing and Building an American City.* Athens: Ohio University Press, 2006.

BIBLIOGRAPHY

A Park System for the City of Cincinnati. Cincinnati, OH: Park Commission of Cincinnati, 1907.

Pelkonen, Eeva-Liisa, and Donald Albrecht, eds. *Eero Saarinen: Shaping the Future*. New York: Finnish Cultural Institute of New York, 2006.

The Plan for Downtown Cincinnati. Cincinnati, OH: City of Cincinnati, 1964.

Poole, William F. *The Tyler Davidson Fountain Given by Mr. Henry Probasco to the City of Cincinnati*. Cincinnati, OH: Robert Clarke & Co., 1872. Reprint, Cincinnati, OH: Cincinnati Historical Society, 1988.

Publications of the American Statistical Association. Vol. 4. Boston: W.J. Schofield, 1895.

Rhodes, Greg, and John Erardi. *Cincinnati's Crosley Field: The Illustrated History of a Classic Ballpark*. 2nd ed. Cincinnati, OH: Clerisy Press, 2009.

Rhodes, Greg, and John Snyder. *Redleg Journal: Year by Year and Day by Day with the Cincinnati Reds Since 1866*. Cincinnati, OH: Road West Publishing, 2000.

Richardson, the Architect and the Cincinnati Chamber of Commerce Building. Cincinnati, OH: Cincinnati Astronomical Society, 1914.

Rogers, Gregory Parker. *Cincinnati's Hyde Park: A Queen City Gem*. Charleston, SC: The History Press, 2010.

———. *Fountain Square and the Genius of Water: The Heart of Cincinnati*. Charleston, SC: The History Press, 2013.

Shannon, Mike. *Riverfront Stadium: Home of the Big Red Machine*. Charleston, SC: Arcadia Publishing, 2003.

Singer, Allen J. *The Cincinnati Subway: History of Rapid Transit*. Charleston, SC: Arcadia Publishing, 2003.

———. *Stepping Out in Cincinnati: Queen City Entertainment 1900–1960*. Charleston, SC: Arcadia Publishing, 2005.

Stephens, Sarah. *Cincinnati's Brewing History*. Charleston, SC: Arcadia Publishing, 2010.

Triplett, Boone, and Bill Oeters, eds. *Towpaths: A Collection of Articles from the Quarterly Publication of the Canal Society of Ohio*. Akron: Canal Society of Ohio, 2011.

Trollope, Frances. *Domestic Manners of the Americans*. Edited by Donald Smalley. New York: Alfred A. Knopf, 1949.

The Tyler Davidson Fountain Conservation Appraisal. Cincinnati, OH: Harry Weese Associates, 1988.

Venable, William H., ed. *Poems of William H. Lytle*. Cincinnati, OH: Robert Clarke Co., 1894.

White, John H., Jr. *Cincinnati, City of Seven Hills and Five Inclines*. Cincinnati, OH: Cincinnati Railroad Club, Inc., 2001.

Williams' Cincinnati Business Directory. Cincinnati, OH: The Williams Directory Co., 1901–18.

Williams' Cincinnati Directory. Cincinnati, OH: The Williams Directory Co., 1848–1941.

Wimberg, Robert J. *Amusement Parks of Greater Cincinnati and Northern Kentucky*. Cincinnati: Ohio Book Store, 2002.

Woellert, Dave. *The Authentic History of Cincinnati Chili*. Charleston, SC: The History Press, 2013.

The WPA Guide to Cincinnati: 1788–1943. Cincinnati, OH: City of Cincinnati, 1943. Reprint, Cincinnati, OH: Cincinnati Historical Society, 1987.

BIBLIOGRAPHY

NEWSPAPERS AND MAGAZINES

Architects' and Builders' Magazine
Bulletin of the Historical and Philosophical Society of Ohio
Cincinnati Chronicle
Cincinnati Commercial
Cincinnati Daily Atlas
Cincinnati Daily Gazette
Cincinnati Enquirer
Cincinnati Historical Society Bulletin
Cincinnati Magazine
Cincinnati Post
Cincinnati Times-Star
Illustrated London News
Journal of the Society of Architectural Historians
New York Times
Ohio Archaeological and Historical Publications
Pittsburgh Press
Queen City Heritage
Railroad Gazette

ONLINE

Architectural Foundation of Cincinnati. www.architecturecinci.org.

Cincinnati Views. www.cincinnativiews.net.

Cinema Treasures. www.cinematreasures.org.

Digging Cincinnati. www.diggingcincinnati.com.

Kings Island. www.visitkingsisland.com.

"Lost Cincinnati: Why Buildings Die." Exhibit at Betts House (2006) and poster series. www.slideshare.net/srisner/lostcincinnati-poster-series.

Ohio History Central. www.ohiohistorycentral.org.

The Ohio Valley Chapter of the American Theater Organ Society (ATOS). www.klugpro.com/ovcatos/RKOalbee.html.

Public Library of Cincinnati and Hamilton County. www.cincinnatilibrary.org.

Queen City Survey. queencitysurvey.blogspot.com.

Smiddy, Betty Ann. "The Legacy of Samuel Hannaford." www.selfcraft.net/Hannaford.

INDEX

INDEX

INDEX

INDEX

INDEX

INDEX

INDEX

ABOUT THE AUTHOR

Jeff Suess is the librarian of the *Cincinnati Enquirer*, where he keeps the newspaper archive and writes about Cincinnati history. He regularly does presentations on local history and leads discussions on graphic novels at the Mercantile Library and the Public Library of Cincinnati and Hamilton County. Jeff also writes fiction and has had stories published by Pocket Books, Post Mortem Press and DC Comics.

Jeff grew up in California and moved to Cincinnati in 1998. He lives in the West Price Hill neighborhood with his wife, Kristin, and their daughter, Dashiell.

Photograph by Angie Lipscomb.